Seabeck

And The Surrounding Area

Fred Just

KITSAP
PUBLISHING

KITSAP PUBLISHING

Seabeck And The Surrounding Area
First edition, published 2016

By Fred Just.
Photographs provided by Fred Just

Copyright © 2016, Fred Just

Paperback ISBN-13: 978-1-942661-39-9
Hardbound ISBN-13: 978-1-942661-71-9

Published by Kitsap Publishing
P.O. Box 572
Poulsbo, WA 98370
www.KitsapPublishing.com

150-10 9 8 7 6 5 4

Contents

Acknowledgments

I would like to acknowledge the many people who helped me gather the information for this book. First, is my wife Eloise who up until her death traveled to many places with me to do research and came up with information I might have missed if she hadn't looked into some of the corners of history. Also my good friend Chuck Kraining of the Seabeck Christian Conference Grounds. His friendship and assistance was a first class bonus to this book becoming a reality. Chuck gave me access to the many documents stored at the Seabeck facilities. Another person that helped me to stay on track was Jerry Hite who helped me with his family history and some of the lost information on some of his relatives. My childhood friend Verne Christopher helped me on remembering people and events that happened during our childhood days. I also owe much thanks to the many customers that graced my restaurant and left material for me when they heard that I was gathering information for a history book of the area. I would come in and find envelopes of family histories and photos on my desk that someone had left with the waitresses for me. Many times there was not a name as to who dropped them off, so unfortunately I am unable to give them credit by name. These drop-offs went on for nineteen years while I had the Camp Union Cookhouse. There are three others that most definably deserve honorable mention are Jerry Houde, Jessie West, and Mike Mjelde (on the shipping and ships associated with Seabeck).

iii

Introduction

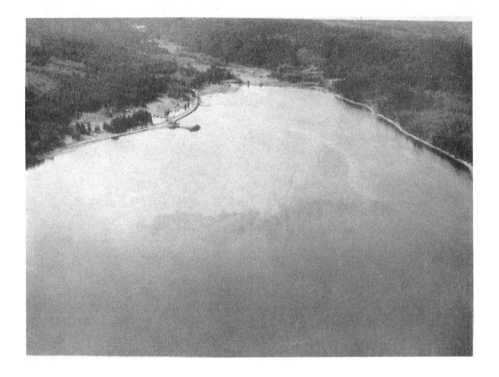

View of Seabeck Bay – circa: 1940

What a lot of the local people do not realize is that some of the local history is buried right up on the hill above the quiet little community of Seabeck. There is a little patch of tangled salal brush, blue huckleberry, saplings and a headstone here and there that is referred to as the Seabeck Cemetery. Many of the people buried there helped to build Seabeck and the surrounding communities. Those few remaining headstones are only a small portion of the nearly two hundred graves concealed there.

View of cemetery after some of the brush has been cleared
Photo from author's collection

Picture, if you will a quiet little cemetery on a hillside, nestled in the woods above a small community that had been one of the largest and most thriving mill towns in a new territory opening up in the 1850's.

Photo showing progress of restoration in 2009
Photo from author's collection

Now! Visualize this same small resting place nearly forgotten; the wooden markers gone, stone markers pushed over and broken into little pieces. Only a few remain intact, but showing the ages of time with their discoloration, the fencing is even torn down (used for campfires), and there are broken bottles and paper strewn about.

This is the scene that met me every time I visited this place. My reason for visiting this secluded spot was to pay homage to my relatives who are buried there. Also, I stopped to pay my respects to some of the others resting there whom I had known in my childhood days.

A person walking among the graves could feel peace and serenity all around. Many times I would stroll through the cemetery looking at the names on the remaining headstones wondering about the person buried beneath the soil. One couldn't help but wonder what stories could be told about these noble people that helped build our community. Sev-

eral of the graves of people I knew, now had no markers. Many of the markers had been destroyed or stolen. Some of the graves only had temporary markers to begin with and never had permanent headstones.

After pondering over these people's pasts, I decided to do research on them and the history of Seabeck and the surrounding communities and record the stories I was told about them. Besides just the research I decided that I wanted to clean up and restore the cemetery.

This book has taken many years to put together. In the beginning a lot of the things I had read and heard seemed logical, but as I gathered documents and did research, I realized that much of it was either mis-construed or downright wrong. Some, unfortunately, made for good reading, but good reading does not necessarily make good truth. The many sources I have used will be printed at the end of the book. Above all, I want the reader to understand that I have made every effort to write the truth.

In the past, the history of Seabeck has been written by other authors who made sincere attempts to relate it. Unfortunately, some of it was based on hear-say, and the wrong information was put into print. I truly hope that my book puts the importance of Seabeck in the Puget Sound into its prospective place in history. Seabeck was a major player in the development of the Puget Sound region. Some of the residents became world known and well respected members of society, but above all, they were like any other American citizen making a living against big and little odds. This is their story.

I will point out to the reader that you will find inserted into the story the names of some of the persons buried in the Seabeck Cemetery with the information I have learned about them. At the end of the book you will find a complete list of the names I have verified to be buried there. There will also be a list of those that could have possibly been buried there.

It is my goal to get as close to the truth of the history of Seabeck and the surrounding communities as is possible. Some will dispute my writings, but I ask them to produce the evidence that I am wrong. I have gone to great lengths to acquire documentation to back up my writings. The gathering of my information came from many different sources. I spent many hours in libraries, government file rooms, interviewing old-timers, museums, and even funeral homes. At one funeral home they would only let me into their records during the night because I would be in the way during the day. For two weeks they locked me in the funeral home at night, and put me out in the morning when the staff showed up. Those nights were spent gathering a tremendous amount of information on some of the people that had lived in Seabeck and the area around it. A final note on what this book is about. It's about a small area of Puget Sound that produced people that left their mark on this area and the world around it.

Chapter One

Indians

When the trappers and pioneers started to arrive in the Hood's Canal region there were only a few tribes in the area. On the Hood's Canal there were the Kolseeds (Quilcenes), Twanas, Du-hlay-lips, and the S'Klallams (Clallams). The Chimakums were more inland south of Port Townsend, and associated with the S'Klallams. There are no Chimakums left today as they have bred out of existence.

In 1855 the Point No Point Treaty was signed and the five tribes were to relocate on the Skokomish Reservation at the south end of the Hood's Canal. The S'Klallams and the Chimakums never moved to the reservation because they were blood enemies with the other three.

It might be noted that of the three tribes in southern Hood's Canal, none of them made permanent camps on the Kitsap Peninsula. There is no indication that they had burials on the Kitsap side until after the white man came. The first Indian burial in the white man fashion was in August of 1878 on the Skokomish Reservation in Mason County. At the first burial the head chief of the Twana Indians made the statement "Today we become white people. At this burying-ground, and no cloth or other articles will be left around, at least, above ground." Prior to that date, the dead were placed in a canoe with their belongings with the canoe then placed on a platform or in a tree. Another method was to just set the canoe on the ground and erect a crude structure over it.

During November and December of 1881 chicken pox, diphtheria, measles, and scarlet fever came through the area and five or six Indi-

ans that died from the white man's death were buried on Point Misery. Through the years the bank fell away dropping the bones down on the beach. Lester Lewis of Lewis Funeral Home, used to own the point and Lester Jr. gathered up some of the bones as they became exposed. It has been several years since any bones have been found.

Although there was never a war between the Indians and the whites in the Hood's Canal area, there was an incident near Port Townsend where a war almost broke out. The Clallams were not happy with the white men. Their leader was called Duke of York, and he led the Clallams for several years. He actually was friendly with the white men. Sometime around 1850 he went by sailing ship to San Francisco. While there he saw that the whites were in great number, and very powerful. Shortly after returning from San Francisco his people wanted to attack the whites at Port Townsend and if they had of done so they would have killed all of the whites because they heavily outnumbered them. When they amassed just outside of Port Townsend to attack, the Duke of York stood in front of them and through his gift of speech held them off for hours. He told them of the white man's power and numbers and that if they killed the white men at Port Townsend the whites would send great numbers and engage in war completely wiping out the Clallam tribe. Thanks to the Duke of York a war was averted.

In the early 1870's there were only about 30 Indians living in Seabeck with most of them working in the mill. By 1880 there were only 59 Indians present in Seabeck. 10 were Clallams and 49 were Twana Indians. At Port Gamble there were about 100 Indians in the early 1870's and in 1880 only 96, most of them Clallams. In 1870 there were only 847 whites living in the entire Kitsap County.

Prior to 1871, even though it was illegal to sell whiskey to the Indians it wasn't strictly enforced. After 1871 one was prosecuted if caught selling liquor to any Indians. Some pretty ingenious ways were used to sell to the Indians. One was that an Indian would go into the bar

with a bucket of clams and offer them to the bartender. The bartender then stated that he would take them in back and see if his wife wanted the clams. A few minutes later he would bring the bucket of clams back out and tell the Indian that they were rotten and no good. The Indian would leave with the bucket of clams with a bottle of whiskey hid in the bottom.

When the white man arrived the Indians celebrated what was called a potlatch. This celebration was where other tribes were invited and there was much gambling, eating, trading, and gift giving. By the 1870's they had pretty much given up the potlatch and began to celebrate the white man's holidays. At first the U. S. Government furnished the food and whatever else was needed. Tables 100 feet long were built and filled with food such as beef, rice, beans, pie, doughnuts, cake, sugar, bread, tea and coffee along with knives and forks. By 1879 the Indians furnished everything themselves.

During the 1870's there was an influx of people settling in the Puget Sound area. In 1872 a Business Directory and guide for Puget Sound was published in Olympia. I've reprinted portions of it to show the reader what may have induced people to settle in this area. This is reprinted in Appendix II.

Chapter Two

Seabeck Spreads Out

Seabeck was the tap root of a tree for all the communities that grew in the local area. Most of the people came to Seabeck looking for a new and better life to work and live in. Some spread out around the nucleus called Seabeck and homesteaded, thus creating communities that carry their names to this day. Two of such communities are Hintzville and Hite's Center. Hintzville was named after Julius Hintz and Hite's Center was named after Ashbel Hite. Lone Rock acquired its name from a lone rock that is on the beach about a half mile north of Big Beef River.

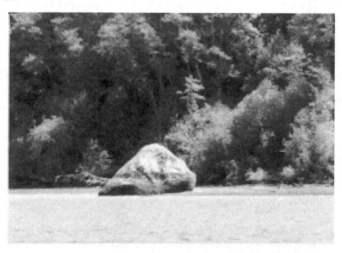

The Lone Rock north of Big Beef Harbor
Photo courtesy of the Schnuits

The following article appeared in the 1924 Washington Historical Quarterly and published as Reminiscences of Joseph H. Boyd. Joseph

with his partner started a ranch between Little and Big Beef in 1859. It is a good picture of the way things were at Lone Rock at one time.

"From Point Roberts I proceeded to Port Townsend where there were several saw mills. One Tibbals ran the hotel, and the place might have had a population of 200. I stopped here for a few days to inquire about work and then went on to Port Ludlow, which is, as I recall, some 20 to 25 miles up the Sound, through Hood's Canal. I found employment in a saw mill at Port Ludlow and worked there for about six months. One day a fellow workman, an Irishman name Tom Clark, asked me how I would like to take up a ranch in partnership with him. I was agreeable and we proceeded further up Hood's Canal to a place near Seabeck where we located our ranch. This land was the finest track to land I have ever seen, and a fine place to live, especially in those days. We soon got up a comfortable cabin and cleared three or four acres of alder and maple growth and put in a crop of potatoes and some vegetables. We had a good boat and passed our time in improving our farm or in hunting and fishing, as we felt inclined. We had always plenty of fish and fowl. One could wade into the creek and catch a good sized salmon by the tail. I have seen a square mile of ducks and geese in the inlet at one time. We had an old flintlock musket and could get all we wanted at any time. On the flat at the mouth of the creek we had a neighbor, an Englishman named Lile or Lysle, who possessed a dog named Caesar.

I stayed on our ranch about six months. My partner, Clark, was very fond of whiskey, and usually, when he drank he was very amusing. About this time, however, we went on a visit to one of our few neighbors. Clark became full, and we got at outs and came to blows. The next morning I said to him, "Tom, you and I have been together about long enough. I have five dollars, and I'll take the boat and you can have the ranch." The next day I took our boat and left, and after going to Seabeck and looking around some, I pulled thirty miles to Port Gam-

ble and there sold the boat and secured employment from Miller in a logging camp at Squawfish Harbor. I worked here about six months. In the early spring of 1861 (February and March) the first news of rich gold discoveries in Idaho reached us and some acquaintances of mine at Port Ludlow wanted me to go to Idaho with them. In May, 1861, we clubbed together and hired a 'plunger', as such sail boats were then called, owned by Sam Alexander, and went from Port Ludlow to Port Gamble, and then to Olympia."

We hear about some of the names that originally founded and built Seabeck such as Marshall Blinn (part mill owner, William James Adams (Ansel Adams the photographer's grandfather), Hiram and Ensley Doncaster boat builders, Edward Clayson (hotel owner, Jacob Hauptly (Justice of the Peace), and later Arn Allen and the Colmans (creators of the Seabeck Conference Grounds). These men definitely were major contributors to this area. In their own way they were leaders that pointed Seabeck in the direction that brought it to the way it is today. But, what bolstered that direction was the workers, farmers, homesteaders, and their families. The names such as the Bergs, Emel, Hintz, Hite, Nickels, Halverson, Brumm, Prosch, and Hauptly are some of the real roots to Seabeck and the surrounding area history.

Scenic Beach was more than likely named for the beautiful view of the Olympic Mountains just across the water. The names of the mountain peaks are Ellinor, Washington, Pershing, Cruiser, Skokomish, Stone, Bremerton, Baldy, Little Brother, the Brothers, Anderson, Jupiter, Warrior, Constance, Boulder Ridge, The Needles, Buckhorn, Iron,

Tribal Ridge, Walker, and Townsend. The true beauty of the Olympics are in the winter when they are covered in snow.

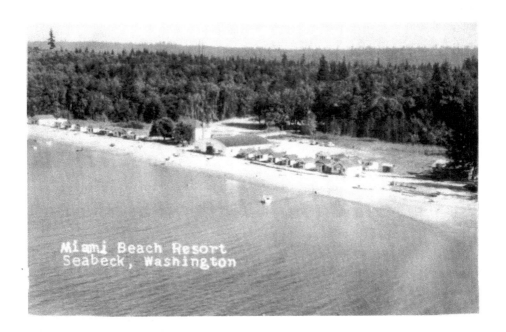

Miami Beach was named because of the vast sandy beach like Miami, Florida.
Photo courtesy of Norma Anderson

Maple Beach was named for the amount of maple trees. Frenchman's Cove, just north of Nellita, was named simply because a Frenchman lived there. In the 1960's, two man-made lakes developed, Lake Symington and Lake Tahuya. Lake Tahuya had been a peat bog before being dredged out for a lake. William Symington dredged out some of Big Beef to create a lake and was the name sake for the lake.

When Lake Tahuya was a peat bog there was two residents residing there. Charlie Turner on the east side and Johnny Hoar on the west. Both used to mine the peat for money. Johnny was also a brush picker and used that to supplement his income. Charlie had a much larger operation and maintained a cabin on his property. He stored his dynamite in the cabin under the bed. When he wasn't working the peat mining he lived in town. He would go out to the cabin every two weeks to

turn the dynamite so the nitroglycerin wouldn't settle and seep through the box. One day he went out to turn the box and it blew up. The blast demolished his cabin and him. That ended the mining of Lake Tahuya for peat. His widow then sold the property.

As to the naming of Big Beef and Little Beef, a couple of possibilities have been put forward. The first one I heard was that when the ships brought cattle in to be unloaded they would push the larger cattle overboard to swim ashore on Big Beef and the smaller cattle at Little Beef where the ships could get closer to the shore. The problem with this theory as I see it is that there was a dock a Seabeck which could be used for unloading the cattle. After all, Jacob Hauptly the local butcher unloaded his cattle there. Also you are taking a chance of the stock drowning and losing your investment. In Jacob Hauptly's diary he refers to Big Beef as Beef Harbor. Several times he would row with others down there for a picnic. He even lost his pistol down there on one trip. My assumption is that to distinguish between the two inlets in conversation that people began to call them Big and Little Beef. Another theory I heard was that there was a beef over the building of the bridges across the two bodies of water. The problem here is that it has already been established that the name of one of them was Big Beef.

Bridge Has Illustrious History

By: Evelyn Sperber

A phone call the other evening from Ernie Emel of Lone Rock suggested now that the county was tearing up the Big Beef Bridge, I should talk to his dad Pete Emel, and get the story of the original bridge.

Pete Emel is a very interesting gentleman and he had a most unusual story to tell. I could have spent the whole evening listening to him and his memories of those "good old days" would have made a book. His sense of humor makes his stories really something.

The year was 1886 and the main transportation routes were the waterways as there were no roads in the area. Pete Emel, Sr. decided to bring his family into the Lone Rock area.

There was only a trail from Silverdale to Lone Rock and it was over this trail that he brought his belongings with a team of oxen that had to be unhitched and led in single file.

It was a very poor trail and part of the way it followed the beach and as Pete Emel Jr., who was but a boy then, remembers it; his brother Frank carried the yoke for the oxen. The other boys, Bill, John and Pete, carried what they could and they settled on 320 acres of land on what is now Pioneer Road.

Mr. Emel had purchased two homesteads, one of which had been owned by a man named Thompson. There were but few families living in the area at the time. The John Johnsons lived on the W. W. Wade place and Jim Smith and family lived on the Big Beef where the cabins now sit.

When anyone had to go to Seattle they rowed out in a boat and flagged down the steamer when it went by Lone Rock, so the trips to the big city were few and far between.

When the first school was built, John Johnson donated one acre of ground and the elder Pete Emel furnished all of the lumber which was brought in by boat and hauled up from the beach by the oxen. The men in the area donated all the labor and a school was built so that the youngsters could get an education.

As more families moved in and the place began to build up, Mr. Emel proposed they build a bridge across both Big and Little Beef creeks.

The neighbors all laughed at him and asked what good a bridge would do when there were no roads to the bridges, but he told them that if they had a bridge the roads would come.

He contacted the county commissioners, and as Pete remembers it, one of them was a man named Bennbennick and his father so impressed the commissioners with his plea for bridges they decided to let them out for bids.

There has been some controversy over why the two creeks were called Big and Little Beef, but Mr. Emel tells me that it was because of the grazing areas up the creeks. The ranchers grazed their beef cattle up the creeks, and the creeks have been called Big and Little Beef since those early days.

When the bids were opened, Pete says his dad had the bid on both bridges for one dollar ($1.00) per foot and he was to furnish all of the material and labor for this price. The Little Beef Bridge was 330 feet long and the Big Beef a little over 800 feet long and it ran out to the sand spit then, rather than on the fill where it is at present.

Mr. Emel got all of the timber off his place and the planks were hand-split cedar that fit so closely together they used no nails. The bridge railing were four feet high and the bridge was sixteen feet wide. The Little Beef Bridge was started in April of 1896 and completed about the 4th of July. It was 30 feet above the water so that small boats could go under and moor in the lagoon as there was 10 feet of water there during the low tide.

The Big Beef Bridge was started as soon as Little Beef was finished and it was completed in October that year.

John Walton was the foreman on the job and many of the workers came from Hazel Point and Coyle and rowed boats across the canal each day to come to work. Jim Simpson and John Walton built the driver to drive the pilling and Pete says his brother Bill tripped the hammer which weighted about 2400 pounds. This was powered by a team driven by Pete Emel Sr.

This bridge was used until 1916 when new piling was driven and it was re-planked. It was then built over the spit and up to the land. It was re-built again in 1942 and the fill was put in. That bridge remained until they began tearing it up a week ago.

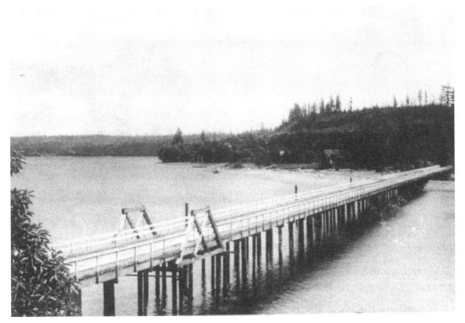

Big Beef Bridge in 1916, Photo courtesy of Seabeck Conference Center

Another name that raises questions is the naming of Crosby. This is a difficult one. According to E. E. Riddell, the name was given by the postmistress at Crosby in the 1890's naming it after her home town in England. Before that it was called Beaver Valley. I do not dispute that this is the truth, but I do know that Riddell made a lot of mistakes in his history. I am not belittling Riddell in the least because he made an effort to record the history of the area by talking to the local residents. Unfortunately he was misinformed by some of the citizens. I have not come across anyone else that took the time or effort to gather local history in the Seabeck area during that period. I praise him for what he did gather.

Now, to get back to the naming of Crosby. Jacob Hauptly homestead-ed in Beaver Valley (Crosby) in Section seven during the 1870's. He hewed out a ranch to keep his cattle that he brought from as far away as Chehalis and Grays Harbor. Mr. Hauptly built a house and planted 200 fruit trees.

What I find interesting is that the name Crosby was a family name known throughout Puget Sound. Also interesting is that one of Mr. Hauptly's daughters (Ethel) married a man with the last name of Cros-by. I have never came across anyone with the name of Crosby as hav-ing lived in Crosby and there is no documentation as to the official naming of Crosby, so the Crosby, England may be accurate and the Crosby family name just a coincidence.

The name of Holly came from the two holly trees that the Wyatts brought from England and planted there. Wyatt Bay was first known as Hammond Bay. The Wyatts first arrived in Holly about 1889 and received the deed on 145 acres in 1891. When the Wyatts arrived there was a white man named Happy Anderson with his Indian wife Mary.

They petitioned for a post office in 1893 and that is when the area was named Holly. Prior to that, the Holly folks had to travel to Seabeck to get their mail. This was a 24 mile trip by boat. Until his death in 1900 Robert Wyatt operated the Post Office and store. For the next

two years a Mr. John Youngblood had a store which he sold to Fred Wyatt in 1902.

Holly circa the turn of the century, Photo courtesy of Verne Christopher

Holly has had several businesses which included a railroad for logging (Riverside Timber Company 1905). The logging company's railroad ran up Anderson Creek and on almost to Hintzville. Also a can opener factory which was ran by power from a water wheel. The can opener factory did not survive so then knives were manufactured. The can opener factory opened in 1902. About that time a shingle mill was

erected and ran until 1910 when the machinery was sold to T. J. Lewis
from Crosby.

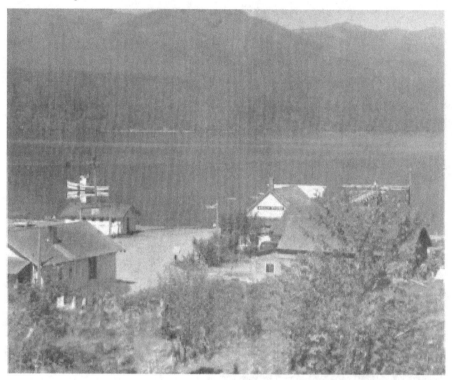

Holly in the early 1940's, Photo from author's collection

The first schoolhouse was in the home of Mr. Rust in 1893 and in
1896 a Mr. George Cady Johnson taught school until 1900. A new
schoolhouse was built in 1905 on the Wyatt property. The names
of the teachers at Holly were: William B. Rust, H. Wells, Miss Inez
Townsend, Miss Mabel Toles, George Cady Johnson, Carrie Holman,
Bertha Gibbs, Christine Bartelson, Miss Jeans, Alma Webster, Mrs.

Martin, Mrs. Whaley, Emma Gantke, Tillie Winton, Rhoda Hopkins, and Mary Nordby.

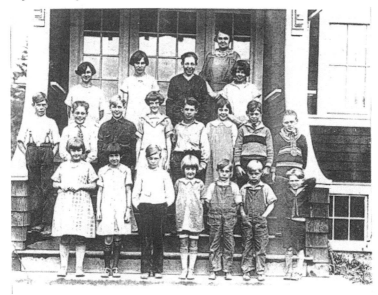

First Holly class in the new two room schoolhouse
Photo from author's collection

I was told that down on Bourke's Point a dance hall and community hall was built about 1903.

In 1909 the winter got so cold once that the southern end of the Hood's Canal was froze over. The steamer "State of Washington" was stuck in the ice at Union City until the ice thawed enough for it to break free. Many of the local folks could ice skate across the canal and back. The freeze lasted about three days.

Camp Union was founded by Tom Murray in 1921. At first it was called Westfork Logging Co. until later it was purchased by the Charles R. Mc Cormick Lumber Company of Delaware. Why it was named Camp Union is pure speculation. I do know that on the payroll records it is called Camp Union. It is possible it was called Camp Union because of the round house that was there.

Nellita and Stavis Bay are two names I have not been able to find out the source of their names. Nellita at one time had a post office and was listed on world maps.

The name Stavis could have come from the Charles Wilke's Expedition in 1841-42. Many places were named after crew members. There is no record of Stavis being named after a crew member.

In 1841 Charles Wilkes sailed into the Puget Sound to chart and name some of the main areas of the shoreline. The United States Government had commissioned him to survey Antarctica and the part of the Northwest that we had purchased from France. He set sail with six ships: Vincennes, Porpoise, Peacock, Relief, Seagull, and Flying fish. When he sailed into the Puget Sound he only used two ships (Vincennes and the Porpoise). He set up his headquarters at Nisqually in the south sound. The bay at Seabeck (situated on the east shore of Hood's Canal) was named Scabock Harbor. Scabock could have been an attempt to spell an Indian name. (Hydrography, Volume XXIII, Atlas, Chart 78). The southwest cape also was charted "Scabock Island." Captain Henry Kellet, in 1847, changed the name of the bay to "Hamamish Harbor," but retained the Wilkes name of the supposed island, changing the spelling to Seabeck Island. (British Admiralty Chart 1911.) When Marshall Blinn built his sawmill on the bay they chose the British spelling and it has remained Seabeck ever since.

Some say that the men that started Seabeck came from Maine and named it after their home town. Marshall Blinn who is credited with starting Seabeck was born in Dresden Mills, Maine. He came to the Puget Sound twice in 1855 to pick up lumber with his ship the "Brontes" first arriving on Jun. 29th and leaving on Jul. 24th and the second time arriving on Oct. 12th and departing on Nov. 10th. After having the University of Washington research for a Seabeck, Maine they came up with the only name Saybec Corners with a population of 50, and it was not located on the coast.

The idea of an island, however, is abandoned and for some reason there is charted in its place Point Misery. (United States Coast and Geodetic Survey Chart 6450).

In 1856 Samuel P. Blinn, W. J. Adams, and James N. Prescott bought into Yesler's Mill in Seattle and each became one ninth owner of the Yesler Mill.

Before continuing on, there is one other name that is said to be the name of Seabeck, and that is the Indian name 'L-Ka-bak-hu' meaning "quiet waters". After researching the Northwest Indian languages, I was unable to find that term. The Dictionary of Chinook Jargon states that the Indian word for water was "chuck" and the word for quiet is "kwann", so quiet waters would be "kwann chuck". A man named J. A. Costello says the word L-Ka-bak-hu means the Siwash. The word Siwash simply means Indian.

Just a quick note as to the naming of Hood's Canal: Captain George Vancouver and his crew of the "H. M. S. Discovery" sailed into the canal in 1778. Vancouver wrote in his journal "Early on Sunday morning the 13th, we again embarked; directing our route down the inlet, which, after the Right Honorable Lord Hood, I called Hood's Channel". What is interesting about the "channel and the word canal" is that in his journal he wrote Hood's Channel and on his excellent charts he wrote Hood's Canal. The fact that the map makers later renamed it Hood Canal is why it is on today's maps as Hood instead of Hood's. Sometimes I'm a bit old fashion, and do not like to see changes. I still refer to it as Hood's Canal. Throughout the book I will use Hood's Canal because I'm a historian and like the name Vancouver put on his charts. Besides, it was still Hood's Canal while I was young and still growing up.

I'm not going to take up the reader's time writing about the discoveries of Vancouver and Wilkes because they are well documented. This sto-

ry is about Seabeck and the surrounding area and the people that were a part of its history.

A lot of time people ask me about road names and other landmarks. The road system developed slowly on an as needed basis. The first major thoroughfare was the Seabeck-Oakland Trail. This trail became a road wide enough for wagon traffic. Parts of it was contracted out to Jacob Hauptly who with his hired help worked on the stretch from Seabeck to Crosby and Seabeck to Big Beef and beyond toward Port Washington Bay (Silverdale) and towards Port Gamble. It should be pointed out that his contract was only for portions of the road. He also was contracted to build part of the road through Seabeck. Richard Holyoke also had a contract for a portion of the road.

A road was built from Crosby to Chico about 1880. This road started from Seabeck-Holly road and Peter Hagan Road crossing Big Beef going east and skirting Green Mountain going on the north side of Wildcat Lake.

A Mr. Olaine supervised the building of the road from Kitsap Lake to the mouth of Big Beef.

Later a road was built from Wildcat Lake to the Seabeck Holly Road and was called Wildcat Lake Road. Later the road was extended from Wildcat Lake to Camp Union and on to the Seabeck-Holly Road. Still later that road was renamed Holly Road. The Seabeck-Holly Road went from Seabeck through Crosby and Hintzville then almost to Nellita, then down to Holly. That road was at one time called the Albert Phunt Road. Another road went from that road down to Nellita. Also a road went off that road and went north to Stavis Bay and onto Seabeck.

In 1909 a petition was signed by several persons to build a road from Holly to Gorst.

During the World War II the Civilian Conservation Corps built a road from Lake Tahuya to what is now the Bear Creek-Dewatto Road. This was called the Gold Creek Road. During the 1960's the Gold Creek Road was straightened out.

Lewis Road was named for T. J. Lewis who homesteaded near there. One Mile Road was built as a shortcut from Peter Hagan Road to the road going to Holly. The interesting thing is that it is only one half mile long.

What is now Bear Creek-Dewatto Road used to be called Lost highway and what is now Lost Highway used to be called Spur Three road. Spur Three was a spur off the mainline of the camp Union Railroad. The spur came north from the now Bear Creek-Dewatto Road following the west side of Morgan's Marsh just about to Hintzville. Morgan's Marsh was an old cranberry bog named after William Morgan who lived near it. The marsh drained north emptying into Big Beef near Peter Hagan Road and the Seabeck-Holly Road. Since most of the stream was on Just property it was called Just's Creek.

Hintzville Loop Road, Christopher Road, Church Road, and Nellita Roads were all portions of the original road going from Holly Road to Holly.

Green Mountain was named after William K. Green who owned most of the mountain. The mountain was part of the Blue Hills as was Gold Mountain. The name of Gold Mountain was named before there was a gold mine at the base. A gold mine always brings forth visions of wealth. Kitsap County's only true gold mine seems to have evoked those visions.

What brought about a gold mine in the first place is that folks thought because the mountain's name meant that gold was there. I suppose that someone had found gold flake in nearby Gold Creek or maybe Lost Creek close by.

The truth is that there are traces of gold and silver in the mine. In 1890 two brothers with the last name of Noah filed a claim. At its peak the mine produced $19.00 per ton of rock. The brothers sank a shaft straight back for about 750 feet. They laid down a track for the ore cart. Their supplies such as tools, dynamite, grub, etc. had to be brought in either on mules or by wagon.

On July 17, 1897 the first ton of gold was shipped to Seattle from Alaska on the ship "Portland". This prompted them to blast the mine shut about 100 feet in from the entrance and leave for the Alaska gold fields.

In about 1925 William K. Green who owned Green Mountain hired someone to re-open the mine. Shortly after opening it up they blasted it shut claiming to have found a rich vein. Immediately they started selling stock certificates. Phony ones. A lot of people bought a lot of worthless paper. Nobody knows where Mr. Green went. He just faded away after selling his property. The mine has been closed ever since.

Johnny Hoar was a local brush picker. He used to hang around the Seabeck store telling stories all the time. He lived at what is now Lake Tahuya before it was a lake. Johnny always liked to tell everyone that he was the only male Hoar in the county. His wife's name was Evelyn and her maiden name was Sutherland. Her ashes are buried with Johnny's ashes in the Seabeck Cemetery. He died in 1970 and she died in 1971.

How W. J. Adams and Marshall Blinn came to pick Seabeck can only be speculated on. For one thing it was a natural harbor with protection from the prevailing southern winds. The land they built on contained a natural lagoon which could be used as a holding pond for logs going into the mill. Other things that could have been factored in were that it was not close to other mills that would compete with them at the time and there were plenty of trees on Hood's Canal next to the water that

had not been tapped into yet. With this great resource of trees so close by, it made it a logical place to set up a mill.

In 1859 the total value of the mill and associated machinery was $20,000.00. Since the machinery for the mill was bought as used equipment in San Francisco, the purchase price was probably much lower. On March 21, 1857 Marshall Blinn, John R. Williamson, and one other filed on the land on the east side on Seabeck Bay under the terms of the Pre-emption Act of 1841. Records indicate that it took from February to September to reach full production in 1857. Before that any records of activity in Seabeck have not been found.

The mill at Seabeck soon became a major competitor for lumber in the Puget Sound. Puget Mill at Port Gamble had been in business since 1853 with other mills opening soon after at Utsalady, Port Ludlow, Port Discovery, Port Blakely, Tacoma, Port Madison, Olympia, and Seattle. By the time Seabeck got up and running strongly, there were about 25 mills located in the Puget Sound. Competition for selling lumber to the ships from San Francisco was fierce. By Adams, Blinn, & Co. building their own mill in the Puget Sound it was a good sound financial move. This allowed them to buy the lumber from themselves under the name of Washington Mill Company. As the demand for lumber rose around the Pacific Rim, so did the Washington Mill Company's profits.

Two major problems for the new mill at Seabeck were getting the logs to the mill and bringing ships down the canal for loading and then getting them back out to the ocean. This prompted a new business, ship building. The first ship to be built at Seabeck was the "Colfax", a tug which was used to pull logs to the mill and to tow ships in and out from the Straits of Juan de Fuca. The "Colfax" was ninety feet long and was powered by paddlewheels on each side. With the prevailing winds out of the south, sometimes the ships could sail out on their own if the winds were from that direction. It might be of interest that the ship

"Oregon" went ashore on Hazel Point while sailing out on her own. She then sat in Seabeck Bay for about a year before she was scuttled.

Several ships were to follow the "Colfax" such as the "Cassandra Adams", Olympus", "Retriever", "State of Sonora", "American Boy", "Henry Winkler", "Louise", "Mary Winkleman", "Georgie", "Eva", "J. M. Griffith", "J. G. North", and the "Richard Holyoke" a tug as was the "Louise".

Some of the history of Seabeck during the 1860's is lacking in good solid facts, although there is a good amount of it available if one wants to take the time to do the research. We do have the names of some of the Postmasters, teachers, and leading citizens. I did acquire a document with a stamp that was canceled by hand at that time by the Postmaster at the source of mailing. The hand cancellation was done by Marshall Blinn.

At the University of Washington the mill records of Seabeck, which involve twenty-some boxes of records are stored, including personal correspondence of the upper echelon of mill personnel, and the scrapbook of Thomas Prosch who was related to Frederick Prosch who at one time had the store at Seabeck. Frederick Prosch is buried in the Seabeck Cemetery. The papers in the Prosch Scrapbook are mill papers that Frederick Prosch found in the attic of the Seabeck Store while he owned it.

Most helpful for establishing dates of certain occurrences, was old newspapers. I traveled from place to place to read articles that would remotely refer to Seabeck or its inhabitants. While President of the Kitsap County Historical Society I had access too many records about the county.

In the 1860's and 1870's, two men arrived on the scene that left a lasting impression on the history up to 1886. Those two men were Edward Clayson and Jacob Hauptly. Edward Clayson wrote a book about

Seabeck titled "Historical Narratives of Puget Sound Hood's Canal, 1865-1885: The experience of an only free man in a Penal Colony". It was copyrighted in 1911. In 1868 he won the mail contract between Port Gamble and Seabeck which prompted him to move to Seabeck. When he arrived in Seabeck he built a hotel called the Bay View Hotel. To say he was a quiet citizen would be the world's biggest understatement. I will explain more about that later.

The diary of Jacob Hauptly was in the care of the Kitsap County Historical Society, and at the family's request it was not to be published. They had very graciously given permission to quote from it and to use it for historical research. From time to time I will quote from Jacob Hauptly's diary to reinforce my writings. In 1866 Jacob Hauptly started his rise to becoming one of the influential people in Seabeck and later Union City. As you will learn, Jacob Hauptly was one of the major players in Seabeck in the 1870's and early 1880's.

Jacob was born in Switzerland June 2, 1830. His family came to the United States via Paris and Le Havre, France, then crossing over to North America by schooner landing in June of 1840. The family came to New Orleans and up the Mississippi River to St. Louis when he was 10 years old along with his four brothers and sisters and settled in Illinois. While coming across the Atlantic another child was born (a girl and she was named Emilia). The family settled in Madison County, Illinois. They lived on 80 acres of land after purchasing ½ of it from the government for $1.25 an acre. An additional 3 children joined the family bringing the number of children to 9. Jacob's father died when Jacob was only 13 years old. At that time Jacob became the man of the family and helped raise his brothers and sisters.

When he reached his early 20's he left home and headed west having many adventures. Before coming to the Puget Sound area he crossed the plains by covered wagon, tried mining in Nevada, worked as a toll taker, and operated a hotel in Virginia City, winding up in San Fran-

cisco. While in Nevada he was part owner of the Yellow Jacket gold mine. From San Francisco he took the steamer "Brother Jonathan" to Portland Oregon, then hired on as a drover to herd over a hundred head of cattle and horses overland to the Caribou Gold fields in Canada swimming the Columbia River three times. Apparently there were only five hundred jobs to be had with about two thousand men there. He then walked four hundred miles to New Westminster, crossing over to Victoria. From there he took a sloop over to Port Townsend and sought work at Port Ludlow. There was no work there, but he was told that there was work at Port Gamble. A paper written by Jean Lindell (a descendant) states the following.

"Not having a boat, Jake and a companion started to walk around the Canal. They soon found out that was out of the question and finding a ship's hatch cover on the beach and some oars, they make a sail with a blanket and tried to sail across, but the wind and the tide were wrong and they nearly drowned before some Indians happened along in a canoe and rescued them"

Not being able to get employment at Port Gamble because he wasn't from Maine, he went to work for a logger named Amos Brown near Duckabush. He continued living in the Puget Sound area until his death in 1928 just short of his 98th birthday.

The other major player in the history of Seabeck was Edward Clayson who published the first newspaper in Kitsap County "The Rebel Battery" (October 1878).

Edward Clayson lived in Port Gamble for three years prior to moving to Seabeck. He was a white male born in Kent England in the year 1839. He had 15 brothers and sisters. When he was 14 he joined the British Navy and remained in the navy until 1864. He married Annie Quinton of Portsmouth, England in 1864. In that year he came to Victoria, British Columbia, after which he moved to Port Gamble, Washington Territory. Two or three years later his wife joined him there. In 1867 they moved to Seabeck with his wife becoming the eighth white woman to take up residency in Seabeck.

One of my favorite quotes of Mr. Clayson is what he wrote in his first narrative. "In our little metropolis at Seabeck we had about sixteen families, and as fine and robust a lot of healthy children as could be found in any part of the earth. "Race suicide," that atrocity from the lowest depths of hell, had not yet put us to the blush; that vileness came with the advent of the railroads, and with that came the quack doctors, the Y. M. C. A.'s, the 'Mental Scientists,' barber colleges, correspondence schools, commercial colleges, etc., and all this keg-meg and combination of infamies conducted by imposters, as they are, with diplomas galore they call progress; if this is progress, then what in hell is damnation?"

Edward Clayson circa 1900

He resented the fact that it was a company owned town and proceeded to be a thorn in the Washington Mill Company's side. In his book he tells of many times he locked horns with the mill's upper echelon and also citizens at times. For example: A rumor went around that his wife had left him. He posted a note on the store's bulletin board denying the rumor in such foul language that Jacob Hauptly tore it down. It must have been pretty bad for Jacob to note it in his diary.

His biggest foe in the mill was a Richard Holyoke who he referred to as Richard Holy-Hawk. Clayson felt that Holyoke ran Seabeck like a ruler and called him King Holyhonshus the First.

Richard Holyoke was the mill manager for the Washington Mill Company, and maintained a strong influence in Seabeck after Marshall Blinn became less involved physically in the operation and moved to Hunt's Point in Seattle.

Sam Nickels and his brother Art had a ferry service between Seabeck and Brinnon. They also had a woman in partnership with them. Her name was Bessie Henderson. She would carry a pack of cigarettes in her bra. If the weather was rough and the passengers got nervous she would take out the cigarettes and offer the male passengers one. She asked, "Would you like a pill? It will calm your nerves in bad weather." The three of them decided to build a hotel and built one on the west side of Seabeck Bay across from the Seabeck store. They called it the Bessamart Inn using the first three letters of their first names. That enterprise failed and the building fell into disuse and the last time I was there it was nothing but a pile of rotting boards in the brush.

Chapter Three

William James Adams around 1850 had built a substantial business with the ownership of a grocery store in Sacramento and San Francisco where he sold goods to the miners. He became involved with the lumber business in the mid 1850's going in partnership with Marshall Blinn.

Marshall Blinn, Photo courtesy of the Seabeck Christian Conference Center

In 1856 Marshall Blinn sailed into Seabeck Bay and unloaded the used mill that he and William J. Adams had purchased in San Francisco. What brought this purchase about was that they had a lumber yard in

San Francisco and had to purchase their lumber from the other mills in Puget Sound. Marshall Blinn had sailed to the Puget Sound twice to buy lumber in 1855 using his ship the "Brontes". They felt if they had their own mill it would increase their profit. Mr. Blinn later purchased the ship "Blunt".

Adams, Blinn & Co. was owned by four individuals: William J. Adams, Marshall Blinn, Samuel P. Blinn, and James M. Prescott. Those four men along with John R. Williamson, William B. Sinclair (the namesake for Sinclair Inlet between Bremerton and Port Orchard), and Hill Harmon formed the Washington Mill Company in 1857. William B. Sinclair later started his own mill at what is now Port Orchard.

It should be noted that in 1856 Samuel P. Blinn, James N. Prescott, and William J. Adams became partners in Yesler's mill at Seattle. John R. Williamson also had a mill on the west side of Elliot Bay (Freeport).

After purchasing a used sawmill, Marshall Blinn loaded it up and went to the Puget Sound to set up a mill on the east side of Seabeck Bay.

Originally there were three settlers on the east side of the bay. They were Grizzly Williams, Marshall Blinn (Blinn was not a settler, he purchased property there), and E. W. Kingsley. On March 21, 1857 filing under the terms of the Pre-emption Act of 1841, J. R. Williamson filed on the land that lay on the east side of the bay. As to who owned exactly what wasn't settled until the Government Survey in the 1870's.

Upon deciding to set up operations in Seabeck Bay, they unloaded their cargo and began setting up the mill. The Washington Mill Company was to be a subsidiary to the Adams, Blinn & Co. Hill Harmon, William B. Sinclair, and John R. Williamson were experienced at mill work as all three had worked previously at the Port Gamble Mill. Working as fast as they could, they managed to erect most of the needed structures by June. These included the mill, hay barn, store,

cookhouse (meeting house), wharf, and blacksmith shop. After a few delays, the mill was up and running by Mid-September.

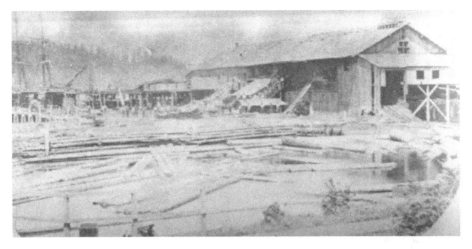

Seabeck Mill circa 1860's, Photo courtesy of Seabeck Conference Center

By the time 1860 arrived only nine dwellings had been built, but that was soon to change. Just a quick note. Between 1858 and 1860 the population of Washington Territory increased by 7,000. As the mill production increased so did the population. In Edward Clayson's book "Historical Narratives of Puget Sound, Hood's Canal, 1865-1885" he summed it up as follows:

"If we make a fair estimate of this strenuous, industrious population, including the hand-loggers, the logging crews, and the Seabeck population, consisting of sawmill employees, the shipwrights, ships' crews, etc., there must have been, at times, not less than four or five hundred of a population, including the families, three-fourths of whom made their headquarters at Seabeck; the rest made their headquarters at Port Gamble."

As Seabeck grew, many things came to be. There were two baseball fields: one at Mr. Clayson's Bay View Hotel and another on mill property on the sawdust pile. The United States Hotel built by William Warin, William Jamison and John Collins (1862) was later named the Eagle Hotel and is still standing on the Seabeck Christian Conference

Center grounds. Another hotel was the Cliff House built by Bill Warin located about a mile to the north of the city to compete with the Eagle Hotel which was owned by Marshall Blinn.

Sometime between 1865 and 1868 a lath mill was added and operated by R. H. Calligan.

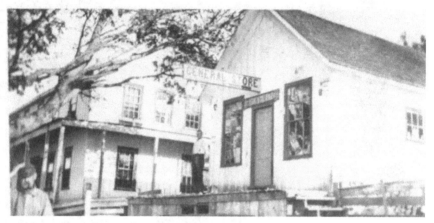

Cliff House with General Store, Photo courtesy of Seabeck Conference Center

The first Cliff House built in 1869 was referred to as the Mad House or Squaw House. Its function was as a saloon and a house of ill repute. Jacob Hauptly mentions in his diaries that when he returned from a cattle buying trip, that the Mad House had burned down in May of

1877. Another Cliff house was built to replace it down on the beach complete with a dock.

The third school district in Kitsap County was at Seabeck (District No. 3). By the year 1878 the length of the school year was six months. For many years the mill company controlled the meetings running the school.

**Original Seabeck School
Later dismantled and rebuilt on
Peder Hagen's property.**
(Photo courtesy Olanie family.)

The following is quoted from "Early Schools of Washington Territory"
1935.

In 1882 a new schoolhouse was built which was claimed to be among
the best structures of its kind on the Sound. After the mill
burned in 1886 the town deteriorated rapidly.

End quote.

Just a little bit on Lizzie Ordway, one of the best School Superinten-
dents to grace Kitsap County.

She was born July 4th 1828 in Lowell, Mass. Miss Ordway was one
of the original Mercer's Girls brought to Seattle in 1864 because of
the lack of women in a new territory. Her education was acquired at

the Ipswich Academy where she learned French, German, Italian and Spanish belter than was expected of a woman of her age.

Of the women that Asa Mercer brought out west, seven of them were teachers from Lowell.

Part of her obituary read: "The little band had to endure much facetious rallying as the matrimonial chances in store for them and Miss Ordway especially provoked the laughing incredulity of her friends by her emphatic declaration that nothing could induce her to relinquish the advantages of single blessedness. Time proved that she had the courage of her conviction as....she was (with the exception of one who returned east) the only woman of the party whom Mr. Mercer took to Seattle who remained unmarried."

The group crossed the Isthmus of Panama and went on to San Francisco then on to Port Gamble. From there they went to Seattle where Miss Ordway stayed with Mr. and Mrs. H. L. Yesler. Along with Mrs. Yesler, Miss Ordway became very active in the work for woman's suffrage.

She was known for being a disciplinarian, but still secured the love and respect of her students. More than once she was asked to take on difficult jobs that had stumped the more skilled male teachers. Miss Ordway taught in Seattle schools for eight years before coming to Kitsap County where she worked her way up to Superintendent of Kitsap schools.

Miss Elizabeth Ordway died September 22, 1897, in Seattle.

In 1879 the following letter was sent to the Territorial Superintendents of schools:

Hon. J. P. Judson Supt. Public Instruction

Dear Sir:

The history of the schools of Kitsap County is a matter that has been lost sight of by the people of the county, no record having been kept, with the exception of a few notes on scraps of paper. According to the best information I can get, I find that the people elected a county superintendent in the year 1858, but no steps were taken to organize districts until 1860, when three school districts were organized, namely Port Gamble, Port Madison and Seabeck. In which of the three places the first school was taught, I cannot say.

Since the new order of teacher's examinations there have been issued by the Board of Education, two first-grade and two third-grade certificates. The amount of school funds for the year 1879 is $3145.08. The teacher's wages range from $35 to $70. The average duration of schools in the county for each year is a little more than eight months. No special tax has been raised. Two new school houses have been built.

We have no graded schools in the county, but districts employing two teachers have classified the children into two grades. Private schools, we have one in successful operation in district No. 1, and one in District No. 3. These schools were started during the summer vacation and have not closed.

Very respectfully, Charles Mc Dermoth,

Superintendent of Schools, Kitsap Co.

Education was offered in Seabeck in 1860 with Mr. Pierpont being the first teacher with school being offered six months out of the year. Prior to that, any formal education was acquired by going to Port Gamble. The first school only had one class room. Later a two room was built. In 1925 a new two room school house was built and used until 1956. The two room school house built in 1925 was built with the same plans as the Crosby and Holly schools.

The Seabeck two-room school house that was built in 1925 was moved by barge by Tommy Monroe to Brownsville where it became a church. The following photos show the school before moving and during the move and after the move.

The following photos are from the author's collection and acquired from the Seabeck PTA.

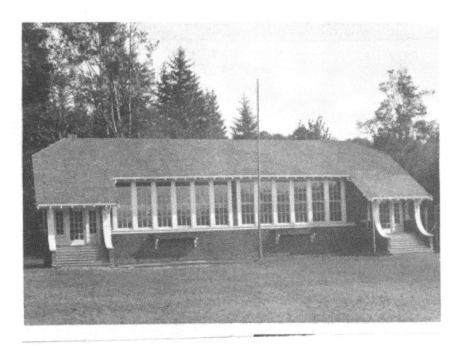

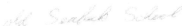

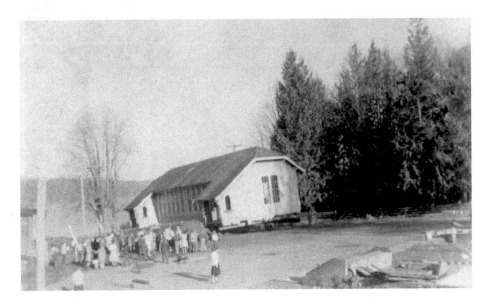

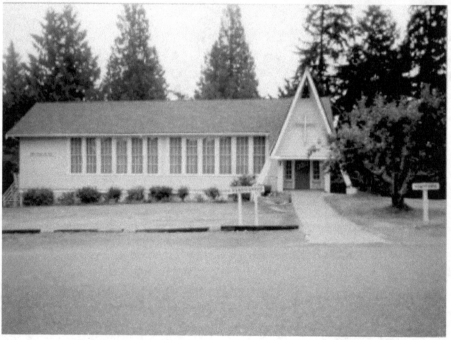

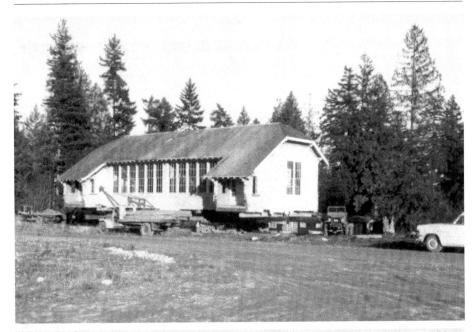

The same year that the two room school was moved a new school was built and the next year the school burned and a new one was built.

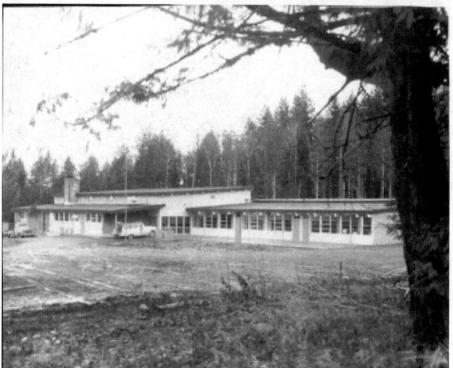

Crosby originally had a one room school house that was built in 1891. In 1916 a steeple and a porch was added to the school. The building burned on February 5th 1976.

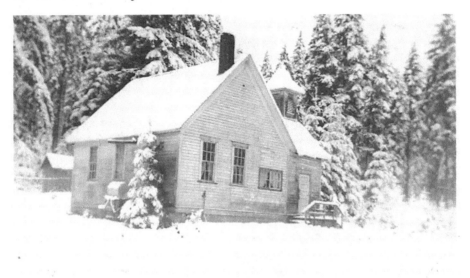

Crosby school after the steeple and porch were added
– Photo out of author's collection

In 1926 a new two room school house was built using the same plans as the Seabeck and Holly two room school houses.

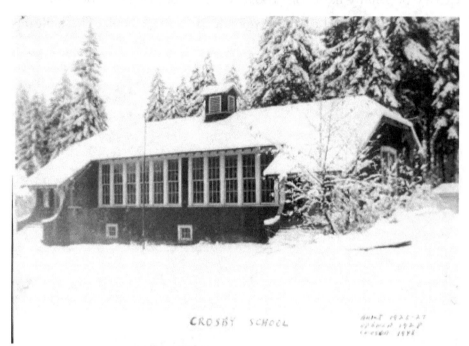

CROSBY SCHOOL

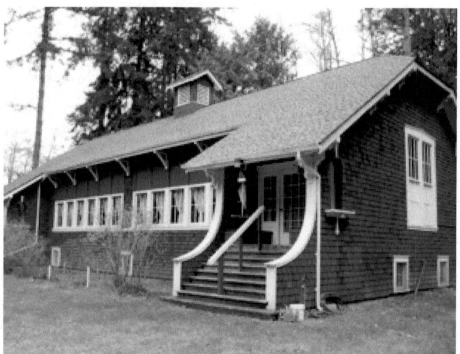

Holly school as it looks at the present, Photo out of the author's collection

Originally Seabeck had a library which was kept in the school house. The books were purchased by the Washington Mill Co. at a cost of seven hundred dollars. Part of the collection of books included works of medicine, religion, history, travel, other cultures, sports, geography, homemaking, humor, recreation, and an assortment of popular novels.

Charles Ried (Jacob Hauptly's brother-in-law, who maintained a diary for several months) mentions going to the library often, using it to his advantage. Evidently the library was made available for use most of the time.

Ashbel Hite was a Civil War Veteran that moved to this area to home-stead and is the namesake of Hite's Center. His wife's name was Alice. They are buried next to their son Robert Bruce. Hannibal Spencer's ashes are buried with Robert Bruce. Ashbel was born Jun. 15, 1847 and died Aug. 16, 1931 and Alice Jane was born Jan. 29, 1853 and died Feb. 28, 1831. Their son Robert was born Sep. 1, 1881 and died Dec. 11, 1951. Hannibal Spencer was Ashbel and Alice's son-in-law having been married to Icia.

Ashbel and Alice Jane Hite in 1930 – Photo courtesy of Jerry Hite

Icia was a well-known painter in her time and only one painting is known to exist. Most of her paintings were scenery themes.

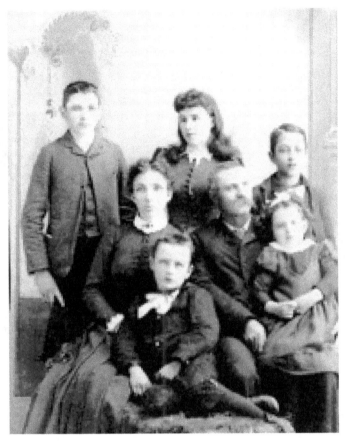

Ashbel Hite family: Front: Robert, Middle l to r: Alice, Ashbel, Sadie,
Back: l to r: George, Icia, and Edward (Photo taken Christmas 1880).
– Photo courtesy of Jerry Hite

Painting furnished by Jerry Hite

Chapter Four

By 1865 ship building was added to the town businesses. The first ship build at Seabeck was a steam paddle side-wheeler tug named the "Colfax". She was named after Schuyler Colfax who became Vice-President of the United States under President Ulysses S. Grant. She was built to pull in sailing ships from the Straits of Juan-de-Fuca, and pull booms of logs to the Seabeck Mill. On March 3, 1883 she collided with a gospel ship and sank. She was immediately raised and back in service by April 11, 1883. She had an insured value of $2,500.00.

A Mr. Charles Murray was the man that built the "Colfax" and also the steamer "Louise" and the "Eva". The machinery used for the "Colfax" came off the old steamer "Caledonia".

Ship building again began in 1872. A steamer named "Georgie" was built by John T. Connick. According to Gordon R. Newell's book "Ships of the Inland Sea", this was a small steamer built to haul freight and passengers between Seabeck and Port Gamble.

It wasn't until 1876 that ship building started in earnest. Then the first ship built was the "Cassandra Adams". The man in charge was Hiram Doncaster and the ship was built in six months. The "Cassandra Adams" set a record for sailing from San Francisco to London in 105 days with a load of wheat. She was a barkentine weighing 1127 tons. The ship was named for either William J. Adams daughter or his wife, as both were named Cassandra. All that is left of that ship is the figurehead which is in a museum on the east coast.

Hiram Doncaster taken in about 1887.
Hiram would have been 47 years old.

Photo courtesy of Seabeck Christian Conference Center

Two of the captains that took charge of her were Captain Delaney and
Captain William F. Edwards. Captain Edwards was born in Maine
in 1847 and started his marine life on the Atlantic Coast in the U. S.
Survey Service. He came to the Pacific Coast in 1866 on the ship
"Live Oak" and joined the schooner "J. R. Whiting" in San Francis-

co, remaining with her until she was wrecked, and then going to the barkentine "Adelaide Cooper" as a mate. He was in the employ of W. J. Adams and company for 18 years, during which he had charge of the Barkentine "Oregon", "Cassandra Adams", and ships "Olympus", and "J. M. Griffiths".

A quote from Wright, Lewis & Dryden's Marine History of the Pacific Northwest: "The American bark "Cassandra Adams", one of the fastest clippers ever built in the Northwest, struck a reef near Destruction Island during a dense fog at 8:15 am, August 16th. She was in route from San Francisco to Tacoma in charge of Captain F. F. Knacke, who succeeded Captain Gatter on this trip. The bark was set on the reef by a strong southerly current, and the island was not sighted until she was hard and fast. It was impossible to save anything from the wreck, which was soon knocked to pieces by the heavy sea. The vessel was owned by the Tacoma Mill Company who had purchased her a few months before for one-third of her original cost. She had an insured value of $30,000.00.

In 1877 the steam tug "Richard Holyoke" was launched on September 15th. After being used in San Francisco she returned to the Puget Sound. At one time L. Harloe was Engineer of the "Richard Holyoke", then came the "Olympus", built early in 1881, the largest single decked sailing ship built on the west coast. Unfortunately her run was short, as she caught fire off the coast and burned in September of 1881. Luckily the ship "Warhawk" was in the area and able to come to the rescue of the passengers and crew.

While the "Olympus" was being built, two other ships were also being built. One was the schooner "Eva", which was about half as big as the "Olympus". The other was the "State of Sonora" ("Estadoes de Sonora") which was being built for the Mexican Government.

The "State of Sonora" was completed in October of 1880 and sent to San Francisco to have her engines installed. She was decked out in silver and brass. Martin Bulger was the superintendent of construction and a Mr. Bell was the master mechanic. At the launching, Etty Clayson (Edward Clayson's daughter) was picked to do the christening. Disaster struck the ship on September 19, 1884. She rolled over in a storm taking 57 lives near the Gulf of California.

The "Olympus" and the "Eva" were launched on the same date (an unusual event in ship launchings). The "Eva" was launched first and christened by Miss Minnie Dagnin and the "Olympus" followed being christened by Miss May Edwards (daughter of the Captain).

In 1881, two more ships slid their way into Seabeck Bay, the Mary Winkleman" and the "Retriever".

The next year brought two more ships being built at Seabeck, the "American Boy" and the "J. M. Griffith".

The "J. M. Griffith" was a barkentine built as a lumber carrier. One of her captains was Jason Mc Naught. In her final years she sailed under the Portuguese flag ending her career in the early 1920's. The "American Boy" was a schooner christened by Alice Nickels, who later married into the Walton family.

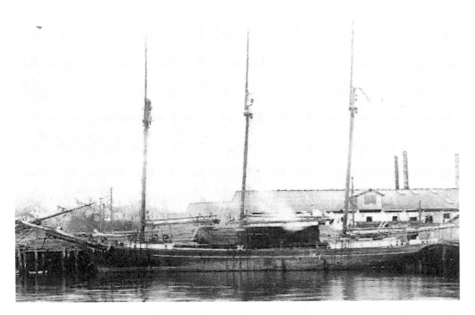

Photo of the Retriever – Photo courtesy of Ensley Doncaster Jr.

The "Retriever" was built with hopes of retrieving the shipping that the "Olympus" lost when she burned. It was sparks from the donkey engine on board the "Retriever" that started the fire which burned the mills at Seabeck. The sparks landed on the hay barn starting it on fire. Then the sparks went to the lumber stacks and from there into the two saw mills and planning mill.

The news of the burning of the mills traveled fast by telegraph. I acquired a copy of the Seattle Times dated August 13, 1886. Some words were unreadable so I substituted a blank line for those words.

SEABECK IN ASHES

Seattle Times August 12, 1886

The great mills licked up by devouring flames; Loss fully $300,000.00---Three hours of infernal heat and flames of 300,000 feet of lumber burnt.

Seattle Times; first by telegram, then by Josephine this afternoon this news that the great mills at Seabeck had been destroyed yesterday afternoon by fire. By____ _____ ____the whistle at about 2

o'clock was the first warning that workmen about the mill and the
citizens of the little village had of the impending disaster. Ten
minutes later large piles of lumber were throwing great tongues
of flames high into the air turning the feeble efforts of one line
of men to stay the ____. The fire caught at the outer edge of the
wharf in a pile of lumber about to be loaded into the bark" Re-
triever", which was then discharging freight by the aid of a donkey
engine. It is supposed that a spark from this engine set the fire.
Piled about the wharves were fully 1,500,000 feet of lumber and the
flames leaped from pile to pile with incredible rapidity. A large
storehouse filled with hay burned most ____, and from there the fire
spread to the two mills, water tank, machine shop, carpenter shop
and other building. There were two mills, the newest being built
but three years ago. Together they had a capacity of 100,000 feet
a day. Adjoining one of them was a planning mill, which went with
the rest. Indeed, the site was swept as with a cyclone, leaving
only the twisted machinery standing silent amidst the desolation.
The slab piles underneath the wharves are still burning and the
air is still laden with heavy smoke and cinders.

Estimate of the loss

At this time it is impossible to correctly estimate the loss. It
is given at from $300,000.00 to $400,000.00 and thus far no report
has been received as to insurance. The mills were the property
of W. J. Adams who at present is in San Francisco. He was tele-
graphed to this morning, and until his arrival no statement can be
made as to the prospect of rebuilding. Fully 200 men are thrown
out of employment and the blow falls heavily on the woodsmen on
Hood's Canal generally. The 1,500,000 feet of lumber burned had
mostly been cut to order, and was awaiting shipping. Captain Mc
Quinlian of the Josephine and Denny Howard who brings the details
says the fire is almost beyond describing. The flames swept under
the iron roof of the new mill like ____ storm and it was impossi-
ble to get within many feet on account of the intense heat. Green
lumber started to burn as readily as the dry, and within three
hours nothing but ashes remained of what in the morning had been
a busy hive of industry.

Narrow Escape of the Retriever

The bark "Retriever" had a narrow escape. She caught fire in her
rigging and along the rail and but for the prompt assistance of
the steamer "Josephine" she too would have gone with the rest.
She was towed to a place of safety but slightly damaged. No one

was injured during the fire. Operatives had ample time to escape
and they could only stand at a safe distance and gaze helplessly
at the rush of flames. If blame can be attached to anyone it is to
those who operated the donkey engine close up against such a mass
of combustibles. Had there been other shipping at the wharves
undoubtedly we would be called upon to chronicle a greater loss.
It is bad enough as it is. One of the famous mills of Puget Sound
has been wiped from existence.

End of article.

The steamer "Josephine" was able to get a line on the "Retriever" and
pull her away from the dock even tho' her stern was on fire. The fire on
the "Retriever" was quickly extinguished. She remained in service for
many years. The last time she was reported as being seen was in the
South Seas with only her bow above water in 1921.

Another ship that deserves to be mentioned is the "Oregon". Originally
she was a side-wheeler. It was the 2nd steamship to come around the
Cape Horn. After being sold to the Adams, Blinn & Co. the boilers
were removed and it was converted to a sailing ship. Captain Henry
was one of the captains. It was condemned in 1881 and set afire in
Seabeck Bay on April 29, 1882. It sank about a ¼ mile north of the
present day dock after burning to the water-line. The boilers from the
steam ship "Oregon" were discarded on the beach at Seabeck and slow-
ly rusted away to nothing having completely rusted away in the 1950's.
In the latter half of the 1900's extensive diving revealed many artifacts
from the hull of the ship.

The following is a quote from Wrights, Lewis, and Dryden's Maritime
History of the Northwest.

"The steamship "Oregon", which played a very important part in early
navigation of the Coast, was built in New York in 1848, and came to
the Pacific the following spring, arriving in San Francisco, March 31,
1849. She was 208 feet long, 33 feet 10 inches beam, and 20 feet hold.

She had three masts, and according to her custom-house register, was of 1,503 tons burden. Her first work on the Pacific was on the Panama route, where she remained several years, having been one of the pioneer vessels of the Pacific Mail Company. On the first trip to Vancouver and Portland in 1856 she was in command of Captain Lapidge. In 1858 Captain Patterson was in charge, and he was succeeded by W. H. Hudson, Francis Conner, H. J. Johnston, Chris and William Dall, Scholl, and others. During the Fraser River mining excitement the old steamer made a fortune for the owners nearly every trip, carrying frequently from 500 to 700 passengers. In 1866 the "Oregon" was running south from San Francisco in command of Dall, and in May collided with and sank a British bark in the Gulf of California. When Ben Holladay embarked in the steamship business in the sixties, the steamer became his property, and he kept her moving until 1869, when he sold to Adams & Blinn Co., the Seabeck mill men, who removed the machinery and converted the steamer into a lumber bark, continuing her in the coasting trade for many years before she was finally laid up. The old "Oregon" will live long in the hearts of the California pioneers as the steamer which brought the first mail from the Atlantic States. She carried 350 passengers on the initial voyage, most of whom left her at Aspinwall, Panama and crossing the Isthmus, joined the steamer again at Panama. The "Oregon" was preceded by the old "California" and followed by the "Panama", all three having been built for the Pacific Coast trade before the discovery of gold was made known in the East". End quote.

Before roads became common place in Kitsap County, the most used method to get from one place to another of Hood's Canal was by boat.

One boat that served the Hood's Canal was the "State of Washington" which was a sternwheeler. It would start its journey in Tacoma and sail around the Kitsap Peninsula to Hood's Canal. Then proceed down the Canal arriving at Union City that evening. After spending the night

there it started back to Tacoma. The "State of Washington" made the trip three times a week. This boat served the Hood's Canal for five or six years.

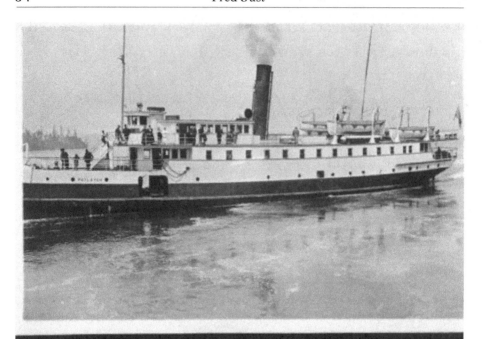

Photo courtesy of Seabeck Christian Conference Center

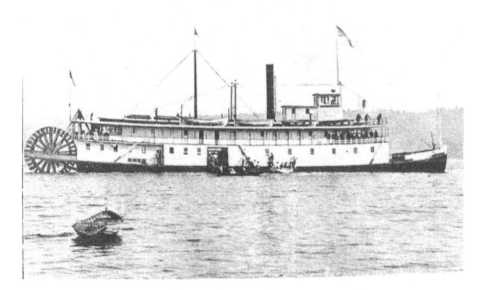

The Steamer "State of Washington" – Photo courtesy of the Houde Collection

The "State of Washington" was replaced by the "Potlatch" a brand new steel hulled boat. This boat would make stops after leaving Seattle at 9am stopping at Whidbey Island and then going to Port Ludlow, Port Gamble, Lofall, Bangor, Hazel Point, Coyle, Seabeck, Brinnon, Duckabush, Triton's Cove, Nellita, Holly, Eldon, Hamma Hamma, Dewatto, Lilliwaup, Hoodsport, Potlatch, and finally Union City about 6:30pm.

Besides the afore mentioned stops the "Potlatch" would stop at logging camps to drop off supplies for them. The camps would have a raft anchored off-shore and the supplies were left on the raft for the camps to transport to shore.

During the summer months a steamer named "City of Angels" was put into service to carry excursionists. The "Potlatch" operated on Hood's Canal until 1917.

Later the ferry service was taken over by Black Ball. The ferry service between Seabeck and Brinnon ran until the mid-1940 and the "Clata-wa" was the last ferry on that run.

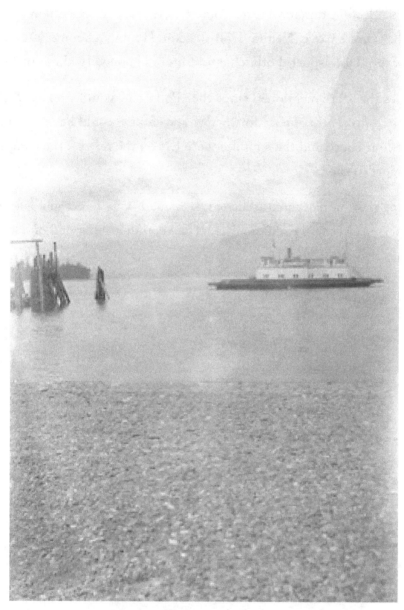

The "Clatawa"

EFFECTIVE MAY 10, 1938
SEABECK - BRINNON
FERRY

"The Scenic Route"

Leave SEABECK	Leave BRINNON
8:05 am	8:45 am
9:25 am	10:00 am
10:40 am	11:15 am
12:35 pm	1:10 pm
1:50 pm	2:35 pm
3:15 pm	3:50 pm
5:30 pm	6:10 pm
7:00 pm	7:45 pm

Extra trip Sunday and Holidays during July and August.

8:30 pm.	9:00 pm

The Short Route Between Bremerton and Olympic Peninsula Points

Seabeck-Brinnon Ferry Co.

Photo courtesy of the Houde Collection
– Courtesy of the Seabeck Christian Conference Center

Many ships made Seabeck their Port-of-call to buy lumber and transport it to other ports. The following list is the information on some of the boats that called on Seabeck for one reason or another.

Abraham Lincoln: This was a sloop.

Alice: This was a schooner. The ship wrecked by running aground on Jan. 15, 1909 at North Beach Peninsula Washington. At the time she was laden with a load of cement. (Pacific Square-Riggers p.20).

Anibal Pinto: Was in Seabeck on June 12, 1877. (Hauptly's Diary)

Annie Larson: She was a barkentine. (Pacific Lumber Ships p.58)

Annie Stewart: She was a small steamer that was part of the Mosquito Fleet. She was purchased by the Oregon Steam Navigation Company. At one time she was owned by Captain L. M. Starr. He purchased it in May of 1885. At one time John H. Kennedy was Engineer.

Antonia: Was in Seabeck on April 10, 1877. (Hauptly's Diary)

Arcturus: She was a barkentine and made many calls at Seabeck. (Hauptly's Diary)

Arling: She was a schooner. (Hauptly's Diary)

Avalon: She was a launch.

Bee: She was a sloop.

Biddy: She was a sloop and the Captain's name was Alex Newland.

Bailey Gatzert: She was a stern wheeler built at Ballard in 1890. Most of her life was between Seattle and Olympia. Later she was sold to the Puget Sound Navigation and put on the Seattle-Bremerton run. She was the first auto ferry to haul cars to the Olympic Peninsula under Captain Harry Anderson. She was named after a Seattle Mayor. Her paddle wheel measured twenty-two feet. She was the boat that

inspired the "Bailey Gatzert March" during the 1905 Lewis and Clark exposition. Her fate was in 1926 when her hull was converted to a floating machine shop on Lake Union.

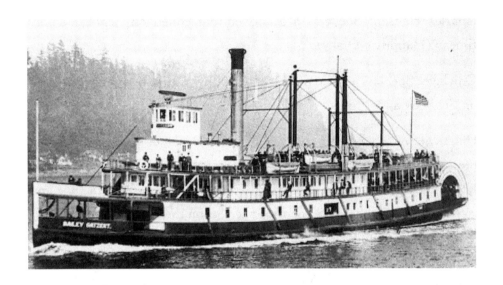

Black Diamond: A steamer that was part of the Mosquito Fleet. She was in Seabeck on June 17, 1877. (Hauptly's Diary)

Blakely: She was a 110 foot steam powered tug that was launched in 1877. At a later date she was converted to a schooner. (Pacific Lumber Ships p.37). She was also a mail carrier contracted by Moore.

Blunt: She was a barkentine owned by Marshall Blinn.

Brontes: She was a barkentine owned by Marshall Blinn. Prior to the building of the Seabeck mill, Marshall Blinn had sailed into the Puget Sound on the Brontes on two occasions. It was the Brontes that he used to carry the used sawmill that he and William J. Adams had bought in San Francisco.

Bushwhacker: A sloop captained by Captain Johnson who made several trips between Port Gamble and Seabeck carrying lumber purchased by Bill Warin to build the Cliff House.

Carswell: She was a sloop captained by Captain Harry Taylor.

Charles Hansen: She was a schooner that called on Seabeck many times. (Hauptly's Diary)

Chiclayo: She was a barkentine captained by Captain Bolin that called on Seabeck many times to pick up lumber. (Hauptly's Diary)

Clatawa: She was a ferry that ran between Seabeck and Brinnon until the 1840's. She was built in 1913 as a steamer being used by the Alki Point Transportation Co. She was then converted to a ferry in 1935 and sold at different times. At one time she was on the Port Townsend-Keystone route. Another time she was on the Kingston-Edmonds route. Later it was sold to Berte Olsen for the run between Seabeck and Brinnon. After that she was sold to the U. S. Navy at the time of the Second World War. She finished her career in 1958 by being destroyed by fire.

City of Quincy: She was a steamer and one of the Mosquito Fleet calling on Seabeck in 1882 and 1883. At one time Captain Irwin B. Sanborn was employed for one year.

Columbia: She was chartered by the Alaska Packers Association. She wrecked at Unimak Pass, Alaska April 30, 1909. (Pacific Lumber Ships p.28) and (Pacific Square-Riggers p.89). While at Seabeck on March 1, 1877 the captain was Captain Johnson (Hauptly's Diary). Arrived in Seabeck on August 27, 1877 and sailed on September 8,

1877. She called on Seabeck up until October of 1882. (Hauptly's Diary)

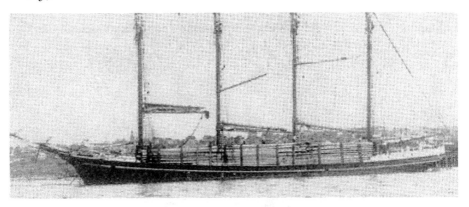

Columbia – Photo from Pacific Lumber Ships

Compeer: She was a schooner that called on Seabeck in the years 1882 and 1883.

Courser: She was a three-masted schooner built at Port Ludlow, 357 tons.

Cyrus Walker: She was a steam tug boat owned by the Puget Mill Company.

Dublin: She was a barkentine captained by Captain Edwards. The "Dublin" made many trips between San Francisco and Seabeck during the years 1874 to 1882. (Hauptly's Diary)

Enoch Talbert: She was a barkentine that called on Seabeck for a load of lumber in 1886.

Erminia Alvarez: She was captained by Captain Alexandre. She picked up a load of lumber in January of 1887.

Estella: Came to Seabeck on September 1st and 2nd, of 1885 to pick up lumber.

Europe: Was in Seabeck on March 30, 1877, April 10th and 19th of that same year. (Hauptly's Diary)

Excelsior: According to Jacob Hauptly she was in Seabeck on January 18, 1881 and August 4, 1882.

Fairhaven: She was a sternwheeler that made stops at Seabeck.

Photo from the Houde collection

Fanny Lake: A steamer that was one of the mosquito Fleet. Built by T. W. Lake as a stern-wheeler for Digs and True. At one time Alexander C. Riddell was Engineer on the "Fanny Lake". Another Engineer was John H. Kennedy.

Fanny Tucker: Captained by Captain Greenlief. On February 26, 1886 there was a warrant swore out against three crew members for mutiny and theft. On the 27th they were charged with Petty Larceny by Jacob Hauptly (He was the local Justice of Peace) and fined $25.00 each and $10.00 costs and sentenced to 14 days in jail.

Favorite: She was a steam powered tug boat (side-wheeler) built at Utsalady in 1868 for the Grennan and Craney Mill. She was dismantled at Seattle, Washington in 1920. She was also a mail carrier contracted by Moore, and commanded by Captain W. I. Waitt. At one

time she was owned by Captain W. P. Dillon. She had an insured value of $10,000.00.

Gem: A steamer that was part of the Mosquito Fleet. She was launched in Seattle in 1878 having been built for Captain George W. Gove who used her mostly for towing. Five years later she was destroyed by fire off Appletree cove February 7, 1883.

General Cobb: She was a barkentine captained by Captain Oliver. She ran aground on February 4, 1880. The ship and cargo was a total loss (Wrights, Lewis, and Dryden's Maritime History of the Pacific Northwest). She was in Seabeck on April 19, 1887, June 1, 1877 (Hauptly's Diary). On July 29, 187, Jacob Hauptly entered in his diary that the "General Cobb" was on the beach. He did not comment on where. On August 8th he reported it as in Seabeck along with other ships.

Gold: She was a schooner that was in Seabeck on May 30, and June 24, 1886.

Goliah: She was a steam powered tug owned by the Puget Sound Tug Boat Company. She had a value of $11,000.00.

H. L. Tibbals: She was a sloop captained by Captain Jim Brown.

Haloyon: she was a schooner. She called on Seabeck in 1882 and 1885.

Henry Buck: She was a barkentine.

Hope: She was a steamer that was one of the Mosquito Fleet.

Hueneme: She was a three-masted schooner built at Port Ludlow in 1877. She weighed 346 tons. She called on Seabeck in 1881.

Iconium: In the January 31, 1860 Seattle Times on page 10 the following was published. "Swan gave other details of year-end business; Ship "Iconium" loaded at Seabeck Washington Mill Co., Capt. Marshal Blinn and Mr. Adams. The ship has 272 spars average 16 in.

center 60 to 70 feet, 175,000 feet of lumber, a quantity of ship's knees, and 6 bowsprits. It sails for Amoy, China on return will stop at Japan, probably to be absent 6 months. Captain Heustis is so well pleased that he will continue in the trade. Fine spars and fine lumber of good quality, fair price and no detention. Captain Heustis thinks the $8.00 per boat from Cape Flattery to any of the mills would be a fair charge for pilots, and from Port Townsend to any of the mills $3.00 per boat will be fair. The "Iconium" was chartered by one of the best houses in China for the trade and her cargo was the first ever carried from the Sound to Amoy."

Industry: She was a sloop captained by Captain Johnson.

Isaac Jeans: She was captained by Captain Boylen and in Seabeck on April 10, 1873, April 27, 1874, June 12, 1874, and August 16, 1874. She was also used to haul ice from Alaska to the Puget Sound.

J. W. Seaver: She was a barkentine that called on Seabeck October 18, 1881.

James Mortie (The Shoo-fly): A steam towboat of the Mosquito Fleet captained by Captain Johnny Brisbane, also captained by Captain I. Smith.

Lady of the Lake: She was part of the mosquito fleet that called on Seabeck.

Lady of the Lake – Photo courtesy of the Houde Collection

Lillie: She was a barkentine. Arrived in Seabeck on March 30, 1877 and April 10th of the same year. (Hauptly's Diary)

Lizzie Marshall: She was mentioned in Jacob Hauptly's Diary on June 8, 1880 and September 29, 1881.

Lone Fisherman: Built by T. W. Lake as a stern-wheeler for Diggs and True. At one time it was captained by Captain Louis Henspeter.

Lottie Carson: She was a schooner in Seabeck September 15, 1882.

Louis XII: She was a French Barkentine. Se graced Seabeck in July of 1882.

Maria E. Smith: She was a schooner captained by a Captain Coupe, and was in Seabeck on February 11th and 23rd of 1882.

Marion: She was a schooner. She came into Seabeck in 1882 and 1883.

Merwin: She was a steamer that was one of the Mosquito Fleet.

Messenger: She was a steamer that was one of the Mosquito fleet. At one time Alexander C. Riddell was the Engineer. Another Engineer was John H. Kennedy.

Midnight Cry: She was a sloop captained by Captain Charley Jones.

Modoc: She was a schooner. In 1892 William J. Maher was on board as chief engineer. Jacob Hauptly mentions her 10 times in his diary.

Nora Harkins: She was in Seabeck on January 5th and July 1st in 1886.

North Pacific: One of the Mosquito Fleet. She is mentioned 21 times in Jacob Hauptly's Diary.

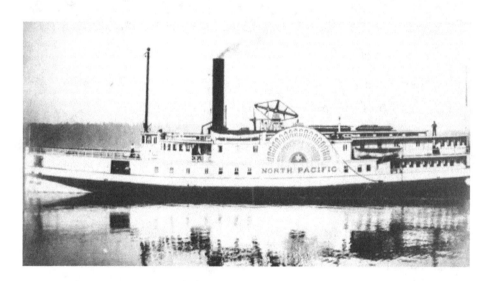

North Star: She was a brigantine. Jacob Hauptly mentions her as being in Seabeck of November 23, 1881.

Norway: She was a schooner mentioned in Jacob Hauptly's Diary 6 times.

Otego: She was a schooner and was in Seabeck on April 6th and 7th of 1881.

Peerless: Launched at Coos Bay in 1878. She was 232 tons. She was in Seabeck on August 4th and 5th of 1885.

Pinto: She was in Seabeck on July 4, 1877. (Hauptly's Diary)

Phantom: A steamer that was part of the Mosquito fleet, and it served Seabeck from 1882 to 1885.

Phinney: She was a sloop captained by Captain George Carpenter.

Potlatch: She was one of the Mosquito fleet that called on Seabeck. It was a steel steamer built at the Moran Yards in Seattle in 1912, especially for the prosperous Hood's Canal run. It would depart from Seattle at nine am and finish at Union City around 6:30pm.

Queen: She was in Seabeck on 1st and the 3rd of November 1885.

Quickstep: She was one of the Mosquito Fleet. She was powered by steam.

The "Quickstep"

Reporter: She was a schooner.

Restless: She was a sloop captained by Captain Higgins, also a Captain J. C. Reed had his first job on the steamer which he held for five years.

Rip Van Winkle: a steamer captained by Frank B. Turner until 1876 after which he went on the steamer Quickstep until 1880. Jacob Hauptly mentions her eight times in his diary.

Ruby: A small steamer of the Mosquito fleet. She was in Seabeck January 3, 1877.

Shark: Owned by Edward Clayson. She was a sloop that was listed as being captained by Edward Clayson who owned the Bay view Hotel in Seabeck.

St. Patrick (Paddy): She was a small propeller driven steamer. She was built at Waterford, Washington in 1874 by James Williams. She was fifty feet long, twelve feet beam, and five feet hold, made her trial trip April 14, 1874, was used for a short time as a towboat on the Columbia, sold in 1876 to D. K. Howard of Seabeck who owned the Eagle Hotel, who took her to the Hood's Canal and operated her on the runs up and down the Canal. She was referred to as the Paddy, and did not have any berths or seating. It was standing room only.

St. Paul: She was a steamer and was in Seabeck on September 7th and 11th of 1882.

State of Washington: She was a stern-wheeler steam boat that plied the waters as a ferry from Tacoma to Union City at the southern end of Hood's Canal. She was also used in the San Juan Islands, It operated in the early 1900's. At one time she was in the charge of Captain W. H. Hobson. Captain Henry Bailey was the last captain.

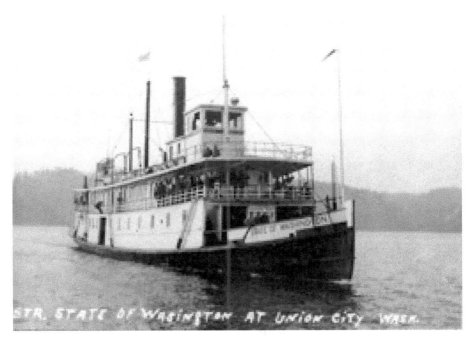

Photo courtesy of the Houde Collection

Tacoma: A steam powered tug built at San Francisco, 136 feet long, 24 feet beam and 12 foot hold. Her first master was Captain John T. Connick. She plied the waters of Hood's Canal pulling rafts of logs. She was in Seabeck February 17, 1882.

Talbot: She was a barkentine.

Tanner: She was a brigantine. Built in 1855. In 1903 she went aground in the fog west of Port Angeles, Washington. She was later refloated. She was captained by Captain Mc Carty. She was in Seabeck on April 6th and April 21st of 1881.

Transito: Was in Seabeck on August 8, 1877 and August 17, 1877.

Union: She was an American barkentine and was in Seabeck on June 12, 1877 and June 20, 1877. (Hauptly's Diary). On a trip from Nanaimo to San Francisco it was wrecked on Clarke's Island, near the entrance to Rosario Straits, on May 7, 1878.

Valparaiso: Was in Seabeck on March 30, 1877, April 10, 1877, and April 13, 1877. (Hauptly's Diary).

Wanderer: She was a sloop captained by Captain Apple Miller.

William L. Beebe: She was a three-masted schooner, 296 tons that was built at Port Ludlow. She was in Seabeck on Nov. 23, 1881.

Chapter Five

Seabeck was a melting pot of nationalities, having residents from many parts of the world. In the late 1860's, Chinese labor was brought into Seabeck having been hired through the Wa Chang & Company in Seattle, and at first were only hired as cooks and servants. Later they were hired for other jobs including mill work. Although there were accidents by the Chinese in the mill, they were not necessary caused by the Chinese as some of the local workers resented the hiring of cheaper labor so they would sabotage the mill to make the Chinese look bad.

This would be a good time to explain the tale of Ah Fong. It has been rumored that a cook at the Seabeck mill would hoard his pay. He was supposed to have hid it in the woods. As the story goes, if the payroll from San Francisco was late, the mill would ask Ah Fong for a loan until the ship came in. At that time Ah Fong would go off into the woods and a short time later return with the amount requested in gold coin. The story continues on, saying that one day Ah Fong went into the woods and never returned. Since then many fortune seekers have searched the hills by Seabeck for the lost gold of Ah Fong.

Now! For the real story of Ah Fong. After searching through the mill records (including payroll records and check register) I was unable to find the name Ah Fong mentioned in any way. While Bergie Berg was alive, I interviewed him and asked if he could shed any light on the story of Ah Fong. After an amusing laugh he shared this with me. About 1910 there was a China-man living on the spit at Seabeck by the name of Ah Fong. He lived there for about two years. While he lived there he ran a laundry doing washing for the local people. No mill payroll!

No gold coins being loaned! No lost treasure! For years people have looked for the lost gold of Ah Fong. There is nothing to support the lost gold story.

The log holding pond was on the east side of the mills in a lagoon. The mills were built on a spit of land that was attached on the north side of the mills. Besides the mills, other businesses were on the spit with the residential area on the east side of the log holding pond where the Seabeck Conference Center is located to date.

During most of Seabeck's hay-days, Kitsap County was the richest county per capita in the United States. This was due to the fact that five of the largest sawmills on Puget Sound were located in Kitsap County: Seabeck, Port Gamble, Port Madison, Port Blakely and Port Orchard. If one could ponder how much lumber was being sawed and shipped to other locations around the Pacific Ocean, then one could understand why Kitsap held that distinction. Interestingly Edward Clayson points out that at that time there were no lawyers practicing.

At this point I would like to quote one of Mr. Clayson's narratives titled "Biddy De Carty and the 'Petticoated Tyhee' Narrative No. 20". This is a good example of Edward Clayson's writing of his feeling about incidents at Seabeck.

Advent of the Chinese

The introduction of Chinese into any town, village or hamlet on the Pacific Coast, ever since it was first settled, was always the establishing of a "Chinese washhouse". This created depot for all Chinese laborers coming to or going from that town. In 1876 the Washington Mill hands, so the advance guard of Chinamen came upon the scene and opened a washhouse next door to Biddy De Carty. Now Biddy De Carty was a very strong, very coarse, very ignorant, very honest "washerwoman", she had two children at this time, and Fred, her husband, a very quiet,

inoffensive fellow, had a steady job in the mill. Mrs. Hollyhawke, the "Petticoated Tyhee" of the town of Seabeck, was the first customer of the Chinese washhouse: this action, or patronage of Mrs. Hollyhawke set the pace, and gave prestige to the "Chinese washer man."

Biddy De Carty was hostile: she annoyed the Chinese washer man in every possible manner; she even went so far as to cut down the Chinaman's wash clothes more than once. "Arrah", says Biddy De Carty, "I left San Francisco to get away from yez and here yez are too, taking me work from me." Of course the little town was all agog concerning Biddy De Carty's fight on the Chinaman, and much sympathy was felt for her, but none dared to show that sympathy or they would be instantly let out, and have to get out of town. But there was one man, Clayson, as usual, who could, and did, exercise the rights of a free man in this "penal colony". By the fierceness of this honest, hard-working woman, the prestige of the mill company was jeopardized; an example must be made of this family who dared to give offense to the "King of Hood's Canal", so Fred De Carty was discharged from their employ and notified to get out of the house. This was in the month of March, when "labor was plentiful". A few weeks previous to this "family outrage" by the "King of Hood's Canal", I had sold a cow to Fred De Carty. As Fred had been "ordered out of town" he very naturally wanted to sell the cow (as he was going back to Frisco against his will). She was a very good cow, but no one would buy her at any price, for fear that they would be suspected of entertaining a sympathy for his "rebellious family;" so up comes poor Fred to Clayson, wanting to sell the cow back to him, when the following advice took place in my bar room in the presence of some of the "Loil" slaves who were only too eager to run down to the company's office and report what I said. Here is exactly what took place: Said I to Fred De Carty, "Do you want to go to Frisco?" "No," said he, "but I am discharged and am ordered out of the house." "Don't you go," said I, "stay where you are." When I told him this he almost fainted. "Your wife," said I, "is selling a little milk and washing

clothes; she is making nearly as much money as you are, and the King of Hood's Canal dare not put your family out of doors in order to favor a Chinaman. If he does I'll set Puget Sound afire with the whole infamous transaction. Now, go down in Port Gamble, "said I; "you can get employment there; you can visit your family here occasionally and as the summer comes along, and men begin to get scarce they will be damned glad to hire you over again." That looked good to Fred, so he took my advice and everything came out just as I said it would. Now I had everything to lose and nothing to gain in standing by these poor people, but when the "miserable ingrates" became thoroughly reinstated (in the slavery where they belonged) they became my worst enemies. You have heard the story of a sympathetic man who picked up a frozen snake in the hedge row, took it into his house and warmed it into life; then the reptile turned upon him and stung him? That was my experience with these miserable degenerates."

End quote. As you can see, Edward Clayson was a very outspoken man.

The mill company tried to control the liquor distribution causing problems for the likes of Edward Clayson who owned the Bay View Hotel that was located on the south end of Seabeck Bay. There seemed to be a constant competition between Mr. Clayson and the United States Hotel for clientele. The Bay View Hotel offered not only rooms but liquor. Mr. Clayson also installed a ten-pin alley (bowling alley) in 1873, and a baseball diamond.

There is one other Narrative of Edward Clayson I'd like to include at this time; it is No. 26 titled "Indian Philosophy".

"All the old settlers of forty-odd years ago in Seabeck and the immediate neighborhood knew "Jack Clams," with that broad grin of his and his old squaw, "Sally Smashrocks."

Old Sally was the most hideous looking creature in human form ever born upon Puget Sound.

These two Indians were totally void of ambition. They had no cares whatever. They never worried about where the next meal was to come from---their food was "all fresh" (berries and clams". They lived in their dirty tent, down upon the beach, in squalor, filth and happiness. Children they had none. To be childless is the saddest of all conditions of the old Indians. Not so, however, with the later generations of Indians. Like all other nations of people, the Indian is prone to adopt all that is worse from the foreigner instead of that which is best. But many of those Indians that have been kept upon the reservations have attained to worthy standards of citizenship. They are, however, nearly all under forty years of age. There are many "half-breeds" of both sexes amongst Indians, who are handsome and intellectual (the improvement, you will observe, comes from the sire, in every case, and not from the dam).

Some of these "half-breeds" of some forty years or more have attained to worthy positions, not by a system of education so much as from the "blood of the sire."

It is very rare that "education" succeeds in raising the full-blooded Indian up to the same standard of proficiency in civilization as the "half-breed."

"You cannot make a silk purse out of a sow's ear."

But to return to Jack Clams. He was both indolent and independent---personal responsibilities he had none. When the tide was out old Sally, his squaw, would go out on the sand with a short stick, dig up a mess of clams, smash them between two rocks, and dinner was ready. But in the course of time they began to acquire a taste for "Boston Muck-a-muck" (American food) so Jack had to go to work once in a while in order to get a little money to buy flour.

The old Indian liked flour and sugar and fruit, but he cared little for beef, pork, or butter. But when his taste for civilized products began to temp him, then he had to work. It was then that his slavery began.

In 1873 the writer of this built a ten-pin alley at Seabeck. It was finished, with balls and pins complete, ready for use on the Fourth of July. "Jack Clams" used to work in my kitchen and help the cook when we were busy. He used to split firewood in the back yard and carry it into the kitchen. He would peel potatoes, clean fish, etc., and would work all day for four bits (fifty cents) and some broken victuals for himself and his squaw.

On the Fourth I hired him to stick up ten-pins, and showed him what to do; and I was to pay him $2.00 a day. Ye gods! This was a charm to him. A big jump from 50 cents a day to $2.00. Truly much money, so Jack began his day's work about 10 o'clock in the morning of sticking up ten-pins. He stuck up for two or three games, and then quit. He came strolling down the alley in a very leisurely manner and with an expression of disgust upon his face he exclaimed:

"What's this?"

"Don't you see?" said I.

"Yes, I truly see this truly useless work. What are you laughing at? American truly big fools."

So I said to him, "You don't want work?"

"Truly not." Said he.

"If you don't work you get nothing to eat." Said I.

He laughed at me in scorn. Said he: "If you don't work, you will get nothing to eat. Lots of berries, lots of clams for me." And with that independent air which he was justified in, he walked off and left us in the lurch. Although subjected to inconvenience by the spirit of inde-

pendence displayed by Jack Clams, I could not help but admire his independence and his philosophy. I did not admire his conduct, by any means, but his position was an enviable one.

There was not a white man in the whole country who could make such a truthful boast as did this dirty, lazy philosophic Indian, who could live upon clams and berries and defy the civilized world.

End of narrative.

Edward Clayson was not the only one to experience that lack of speed by Jack Clams. Jacob Hauptly was at his leased ranch at Colseed and needed to get across the Canal to Seabeck so he hired Jack Clams to ferry him across in Jack's canoe. Under good conditions a person could row across the Canal in less than an hour and a half. On Sunday July 8, 1883 Jacob Hauptly made the following entry in his diary:

"At 7:30 am I left ranch for Seabeck with Jack Clams, we got to Seabeck by 11:30. Hard work to lie in canoe for 4 hours."

There were many people that had run-ins with Edward Clayson. One time someone started a rumor that his wife had left him and went to Portland. Mr. Clayson was so mad that he posted a notice on the store bulletin board. The note was so obscene that Jacob Hauptly took it down.

Mr. Hauptly mentioned in his diary about having a hard time getting Mr. Clayson to pay his bills. On Feb. 3, 1883, Mr. Clayson jumped on his horse and left town going to Olympia and then on down to Portland, Oregon leaving behind a $450.00 liquor bill and owing Jacob Hauptly for the previous beef bill. His family left the next day.

At this time let me tell you more about Jacob Hauptly. As mentioned before he was born in Switzerland in 1830 and came to Seabeck in the 1870's. He arrived on the west side of Hood's Canal in the 1870's where he rented a farm. In the early 1870's he moved to Seabeck and started

a slaughter house. Also he built a large enough home to take in board-
ers. This man was not one to set idle. He lived to be almost 100 years
old and had a very active life. During his life he owned property in
Crosby, Seabeck, Union City, Bell Town in Seattle, and property south
of Hoquiam in Grays Harbor.

Mr. Hauptly was a man of many jobs such as Justice of the Peace,
butcher, farmer, hotel owner, bar owner, livery stable owner, and freight
line owner, Postmaster at Union City, grocery store owner, and grave-
yard keeper at Seabeck and later at Union City.

His honesty is much evident in his diaries as to when he went to Mr.
Brinnon and borrowed $100.00 on just his word. At that time $100.00
was not a small amount of money.

He bought his cattle in locations around the Puget Sound and Cheha-
lis/Grays Harbor area. Since his father-in-law lived in the Montesano/
Elma area, Jacob would sometimes use Mr. Newman's ranch as a hold-
ing place for his cattle until he was ready to herd them to Seabeck. The
cattle he bought were herded overland to his ranch at Crosby and his
holding yard at Seabeck. Many times he purchased sheep and herded
them to Union City then put them on one of the two barges he owned
and had the barge towed to Seabeck. His diaries also mention buying
chickens, turkeys, and butter.

On one of his trips he purchased 100 sheep and herded them into
Olympia and put them in a holding pen. Unfortunately they got loose
and ran all over the city. It took about four hours to round them up.

On May 29, 1880, Jacob Hauptly married Louisa Reid from Grays
Harbor County. Jacob turned 50 years old four days later. Louisa was
18 years old, and she died June 15, 1898 due to a miscarriage at the
age of 34. Jacob re-married again to a Lena Mickelson from Belfair
on February 5, 1904 who was 28 years of age and Jacob was 73. Lena
died September 13, 1918 of tuberculosis at the age of 41. Both women

were less than half his age when they married him, yet he outlive both wives.

While married to Louisa they had four children that survived: Mary, Harry, Cleve (Cleveland), and Ethel. Cleve, unfortunately, died saving his father's diaries from a house fire four years after his father died who died in 1928. All the diaries from 1900 to Jacob's death were destroyed. The diaries that were saved have been a treasure trove for the local historians. Louisa had several miscarriages and one still born child that was not named and is buried in the Union Pioneer Cemetery at Union, Washington. Louisa is also buried in the same cemetery.

Photo out of author's collection

Being that Louisa was married to Jacob, she was able to live an above poverty life style having a seamstress to sew her dresses for her. By all indications in Jacob's diaries she must have been hard to satisfy because he seems to always be looking for someone to go to work for her. When one was hired it seems she didn't last long.

When she and Jacob went to Seattle, she spent a lot of time shopping. Where Jacob was frugal she was not the same. Many times she also took her friends with her.

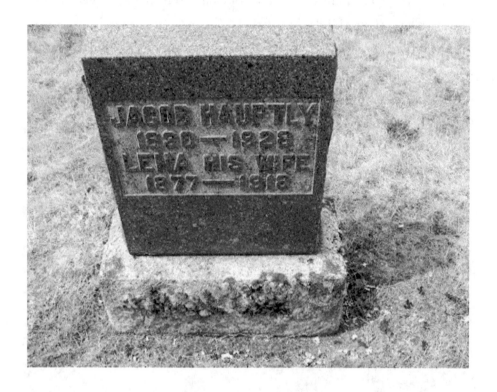

Jacob Hauptly and his wife Lena are buried in Shelton
– Photo from author's collection

In my research of the history of Seabeck I have leaned heavily on Jacob Hauptly's diaries for cemetery names and verification of events while he was in Seabeck. Jacob was a very important member of the community even though he was not a part of the Washington Mill Company echelon. His everyday entries give a very good description of everyday life. After reading his diaries I came to realize he left us a legacy of a slice of life the way it was in the late 1800's. It is evident that during his early days at Seabeck his mother lived with him. There is no indication as to when she ceased to live with him, although in one entry after he married Louisa he mentioned going down to the spit with his

wife and mother to have pictures taken. He also mentions his mother in other entries.

He had several brothers and sisters with whom he corresponded with through the mails. One of the brothers (Gottieb) who lived back in Illinois was asked by Jacob to move out here and settle. He declined Jacob's offer. There was a sister (Mary Coffee) that lived in San Francisco that he visited.

Sam Bassett is also buried in an unmarked grave as his wife Anna. He was born in 1850 in Wales England, and died June 23, 1940. He was a member of the Crosby Community Club. He also wrote under the pen name of "Brutus" for local newspapers and he wrote many obituaries for local deaths. After his wife died he tried to 'spark' Nancy M. Just. Sam always carried a cane and chewed tobacco which drooled down his chin. She had no interest in him although she was kind to him. One night when visiting her he stayed till after dark, so she asked her grandson Melvin E. Just to walk Mr. Bassett home. Melvin did not like Mr. Bassett. Shortly after leaving Melvin came back home. When questioned about why he was back so quick, he said that Mr. Bassett told him that he could make it on his own so Melvin could go on back home. At that time Mrs. Just's son Lester had taken out some large stumps so that the garden could be extended. One hole in particular was rather deep and muddy. It was found out later that Melvin had led Mr. Bassett into the hole and left him there to make his own way home. There is no record of Melvin's punishment.

Chapter Six

The feud between Edward Clayson and the Washington Mill Company involved several accusations by Mr. Clayson. He felt his biggest accomplishment was the publication of his newspaper "The Rebel Battery" in October of 1878. The cost was fifty cents per copy. Only one copy has survived, and there is no record if he published any other issues. The newspaper was slanted almost entirely against the Washington Mill Company and Richard Holyoke. While copying his paper it was not possible to make out some words. In that case I put in a blank. The following is a copy of his paper:

THE REBEL BATTERY

SEABECK, KITSAP COUNTY, W. T., OCTOBER, 1878

Volume 1 Number 1.

THE REBEL BATTERY

PUBLISHED OCCASIONALLY AT

SEABECK, KITSAP COUNTY, WASH. TY._____

EDWARD CLAYSON, Sole Editor and Proprietor_____

Single Copy: Fifty Cents

THE REBEL BATTERY will be devoted principally to the interests of the settlers

And Loggers of Hood's Canal

SALUTATORY

 In introducing ourselves to the public, we wish to be distinctly understood that we have neither the education, nor the ability necessary to conduct a newspaper, nor do we aspire to be considered as making any such attempt. Having never followed any other occupation but that of a laboring man, and having never attended school

since we were eleven years of age, we fully realize our inability to assume the position of an editor, consequently we cannot justly claim the attention of the public generally. It is only those who have been subjected to the influences which we propose to expose, who can fully realize the situation, and to whom we can look for support. It does not, in our estimation, require much of an education or ability as a writer, to publish a few plain truths. The ones which we here assumed for our little sheet, The Rebel Battery, etc. does not imply that we intend to rebel against any lawful authority but, on the contrary, we shall always endeavor to be a good, law-abiding citizen; but we wish to be considered as rebellious, in the extreme, to the tyranny, persecution and indignity which we have been subjected to for the past ten years, and shall ever be ready to open the ports of The Rebel Battery and give a broadside to the tyrannical oppressors who would make the whole of Hood's Canal nothing more than a penal colony, with its headquarters at Seabeck; with its Governor and staff of officers with unlimited power to dictate whatever terms they chose to their Subject.

We don't expect to be of sufficient importance for the press of the country to notice, unless it be to hold us up to the ridicule of the country as presuming too much; as an amateur in the business, we naturally expect to be ridiculed by the old scholars who can wield a more powerful pen, or would endeavor to make capital by defending tyrannical despot.

The Washington Mill Company

CONTRASTED WITH OTHER MILL COMPANIES ON PUGET SOUND, AND THE MANNER IN WHICH THEY GOT RICH SO FAST.

Washington Mill Co., indeed, we wonder every American within the range of at least one hundred miles of Seabeck doth rise with indignation and protest against the name of Washington being prostituted in any such manner. It would be far more appropriate to name the concern after Boss Tweed, as they have certainly followed more in the steps of Boss Tweed than those of Washington; we have been in this town over ten years and know just what we are talking about. This concern known as the Washington Mill Co., have got rich principally by theft, and about the only talent which their agent here possessed when they took him under their wing and placed him in the position he now occupies, was that he was the most successful thief in his time. If the Secretary of the Interior wants to make an example of any mill company on the Pacific Coast, we don't know of any one which can be as strongly

recommended to his notice. As this concern known as the Washington Mill Co., located at Seabeck, W. T.; has any other mill company on the whole coast enjoyed the same facilities for stealing? Look at their geographical position centrally located on Hood's Canal, where the forests run to the water's edge, where the water may be crossed almost any time in a small canoe, consequently it is not necessary for them to keep anything but an old flat bottomed tug to bring their stolen logs into Seabeck. The other mill companies on the Sound have worked to great disadvantage in this respect. They have been obliged to keep up expensive steamers for years, in order to get their logs to the mills, and we often hear of them losing boom after boom, consequently sustaining great losses, which the Washington Mill Co. have never experienced. Is it any wonder, or credit either, for them to take precedence of almost every other mill company on Puget Sound, taking everything into consideration! We don't see how the other mill companies on the Sound manage to compete with them either in the San Francisco market, or in the foreign markets, that look to Puget Sound for lumber. Some people who are ignorant of their practices will say that they are enter-prising; so was Boss Tweed, they will also state that they employ a large number of people, so did Boss Tweed, they will also say that they spend considerable money in making improvements; Boss Tweed did the same thing; he spent a large amount of his dishonest gains in building, etc., etc., giving employment to a large num-ber of laborers and mechanics, and there was a time when no man in New York City, dared publish a word against him, consequently he felt just as safe and defied the law just as much as the Wash-ington Mill Co. are doing today. This concern known as the W. M. Co., has, during the last seven years, settled up three estates of its former members amounting to several hundreds of thousands of dollars; have built large ships and steamers and an additional sawmill, besides spending tens of thousands of dollars in this town, and have acquired several thousand acres of valuable timber land, probably not less than $75,000 worth. We ask, is there any other mill company on Puget Sound that can make the same showing in the same length of time? We believe not; and why not? Not because their members and agents are not as smart as those of the Washington Mill Co., but because they have not employed the same facilities for stealing lumber.

The yoke which the whole inhabitants of Hood's Canal are expected to be under---Whol(e)yoke.

Page 2

THE REBEL BATTERY

SEABECK, W.T. October 1878

All correspondence to the Rebel Battery must be addressed to

E. Clayson Seabeck, Kitsap County, W. T.

That Twenty-four Thousand Dollars

WHICH CLAYSON HAD AGAINST THE WASHINGTON MILL CO. AND HOW IT CAME
ABOUT SHOWING THE INCAPACITY AND TYRANNY BY KING RICHARD AND HOW
HE WAS SLAIN WITHHIS OWN WEAPONS.

On a certain date, Mr. Clayson gave the Washington Mill Co. a
written notice to remove their logs from off his premises or the
ground rent would be $20 per day. They at once recognized his
claim by taking a number of men and a steamer and removing the
logs: at the same time they nailed this notice up on the outside
of the store, the object of which was to subject Mr. Clayson to
the ridicule and criticism of their dirt-eaters. Some of the poor
miserable creatures (the king's loyal subjects) felt greatly elat-
ed by the circumstance, and showed their loyalty to their king
by various gestures and remarks which they thought would please
their master the best on this occasion. But little did the king
think that it would be possible for Clayson to humble him in the
presence of those same subjects through the very same instrument
he was now making use of for holding him up to public scorn. Af-
ter a few weeks, when the excitement was all over and everything
had cooled down, Richard, without further ceremony, took posses-
sion of Mr. Clayson's premises. At the expiration of three and
a half years, Mr. Clayson presented his bill for rent, which now
amounted to almost $24,000, and the very fact of that notice hav-
ing been nailed up on the outside of the W. M. Co.'s store three
years and a half before, for the sole purpose of subjection Mr.
Clayson to the public scorn, was now evidence against his majesty
and could be used to establish a claim for $24,000, that's paying
rather dear for a day or two's sport. It was really surprising to
see how courteously Mr. Clayson was received on this occasion; he
was invited into the king's private sanctum, and treated with the
greatest respect. After a long consultation with his majesty, a
settlement was made for about $1,000, and Mr. Clayson left the of-
fice with the gratification of having humbled a tyrannical despot,

which was more satisfaction to him than to have presented the case
and collected $24,000.

Dirt-eaters classified

Servants obey your master

No. 1---Is a natural dirt-eater constituted as such by nature he
cannot help himself if he would. As a general rule, he will work
for any wages his Master determines to pay him; and will spend the
money wherever he thinks it will please his Master the most. His
master, (or his owner, which is more appropriate) can rely on him
all the time to do his bidding, no matter what the task may be, and
after all this he feels flattered if he should be so favored as to
receive a grin or an insignificant glance from his master!

No. 2---This class of persons are those who have no particular ob-
ject in life---are not self-reliant. They go in for a steady job,
"Wages no object," whatever: they accept no responsibility, but
plod along in a state of subserviency, all their greatest aspira-
tions being to please their master.

No. 3---Are those characters who eat dirt for money and not from
principle---generally to be found in positions where the highest
wages are paid.

No. 4---This class of the fraternity may very properly be called
"the Chief dirt-eaters:" they enjoy special privileges under their
masters, and are calculated to control the actions of their kind,
from time to time, according to circumstances: they are generally
aspirants for office and are calculated to run the whole machine,
both socially and politically---in the best interests of their
masters.

Reading the Declaration of American Independence to such charac-
ters as above described, is the greatest mockery and indignity
which that justly celebrated document can possibly be subjected to.

Whom the cap fits let him wear it.

We were greatly amused the other day, at seeing a number of the
Washington Mill Co.'s hogs arching up their backs and forming a
hostile attitude towards some of Clayson's hogs as they passed qui-
etly by: they (the hostile hogs, we mean) are evidently dirt-eaters
of the 5th class, and are anxious to fraternize with their two
legged brethren, as they appear to fully realize the situation.

One of the Chief dirt-eaters remarked to a farmer of Hood's Canal,
that he (the farmer) would not have any place to sell his produce

if the mill company was not here: forcible argument in support of his Master, just as well say that the mill crew would have nothing to eat if the farmer was not here.

County Commissioner! What a farce! We doubt very much of the Commissioner under his oath of office dare advocate anything at the county seat which would conflict with the wishes of his august majesty as to how he shall serve his master's special interest; he is calculated to anticipate the same and act accordingly.

That celebrated writer, Lord Macaulay, remarks that tyranny and oppression may exist for ages and ages, where there is no free press. Surely, the people of Hood's Canal fully realize the truth of his remarks.

Page 3

The Whiskymill Owner Contrasted With the Sawmill Owner.

The man who sells liquor and is generally treated with the greatest indifference by the sawmill owner as something beneath his notice, is an exemplary character in comparison to the lumber thief; in the first place he pays a license to the general government for the privilege of selling liquor; secondly, he pays the city, town or county another license, thereby swelling the revenues of the general government, also the particular county in which he does his business, the law also requires him to give bond to conduct his business in an orderly and respectable manner; he also has to satisfy the officials granting the license that he is a man of good moral character.

What a contrast when considered in its true light! Which man of the two has the most demoralizing influence on society, the saw mill man or the Whiskymill man? A boy is born and brought up in a sawmill town; he learns year after year, as he grows older to look up to the mill owner, that he (the mill owner), is an exemplary character; that he is worth so many thousands of dollars. He sees one step out with his hundreds of thousands, and still another, and another, with their tens of thousands of dollars; he also learns how these large fortunes have been made. Why should he not when he grows old enough, use every exertion he is capable of both mentally and physically, to grasp at any dishonorable project which presents itself? He is taught from his infancy to admire, respect, and pay homage, to those who have done the same thing and made themselves makers of the situation by dishonorable and tyrannical means.

The privilege which Boss Tweed's Subjects Enjoyed, which King Richard's Don't---They could spend their money in what store they pleased, travel on what steamer they pleased, and were never questioned about what hotel they patronized, and last, but not least, they could always get the money which they worked hard for, when it was due and demanded.

Another Chinaman arrived by yesterday's boat for the Palace. This makes seventy-five all told during the past year. A Chinaman will stand for anything, but that place is too hot for them.

SLAVERY IN SEABECK---FIFTEEN HOURS CONSTITUTES A DAY'S WORK.

Yes, we repeat, it is slavery of the worst kind, when men are

forced to do it against their will. Show us the man who works
willingly after supper three hours for the miserable pittance he
receives for his services? Two men were discharged for not putting
in an appearance after supper. This, we presume is an example to
the balance of the crew to let them see what they may expect for
insubordination. Those same two men worked faithfully for the
company for two years 12 ½ hours per day, and when they tried to
compel them to work three hours after supper they would not stand
it. Twelve and one half hours per day is long enough for any man
to work all the year round, if this companies behind in orders so
much, why not put on a night crew as is done in other mills on the
Sound under similar circumstances? If all the men were to quit,
who are actually working against their will after supper there
would be none left but the dirt eaters. This article will furnish
material for the dirt eaters to talk about; they will be found
backing up their masters on the subject.

Hood's Canal

Hood's Canal is a large sheet of water some sixty miles in length,
and from one to three miles wide, with small rivers and bays on
either side, where is to be found quantities of good farming land.
Quilicene lays some fourteen miles N. W. from Seabeck, offers good
inducement for settlers, as there is a large quantity of good
farming land in that section of country open for settlement; it is
impossible for such lands to remain vacant long, with the facili-
ties which Hood's Canal now offers for travel. Seabeck is a large
sawmill town located on the east side of the canal almost nineteen
miles from Port Gamble; the mill cuts not less than 70,000 feet of
lumber per day, besides laths and pickets, the greater portion of
which finds its way into the San Francisco market, although quite
a number of large ships land here every year for foreign ports.
It has only one store, at present, belonging to the mill company,
although there is business enough for two. There are two hotels,
one belonging to and under the immediate patronage of the mill
company, located on the sawdust; the other belonging to an outsider
by the name of Clayson, and supported by respectable people, who
paddle their own canoe regardless of local influence. Seabeck has
also a good meat market, shoemaker shop, good school, brass band,
baseball club, fruit stand, shaving salon, etc., etc., in fact, ev-
erything necessary for a small community except, FREDOM OF ACTION,
the town unfortunately being governed by a king. The next town
of any consequence is Union City, 28 miles south from Seabeck,
supported principally by the lumbering done in that part of the

country. There are also quite a number of settlers at the head of
Hood's Canal, about fourteen miles from Union City. The Skokomish
is the largest river on Hood's Canal, its entrance being in the
immediate neighborhood of Union City, the Indian reservation being
on one side and a large farm belonging to Mr. Webb on the other;
there are also several other settlers on the river. The farming
lands on this river are very rich offering inducements to settlers.
The fishing business on Hood's Canal will be of some importance
before many years.

Approaching King Richard Under Difficulties

We had a presumption as a citizen of the United States and a tax
payer of this precinct to approach King Richard, and to call his
attention to the dilapidated condition of a certain bridge in this
neighborhood, to which he replied haughtily and with a majestic
wave of the hand that he did not want a bridge there; to which we
postured the assumption that it was very necessary to our co-ex-
istence and we should strive to keep one there. Our presentation
so infuriated the King that he actually forgot his position in a
moment of anger and shook his fist violently in our face and threat-
ened to "bust" us right there, to which we replied that he had
extended the whole of his mental faculties in trying to "bust" us
and was now resorting to brute force.

 Sawdust---Seabeck is the first seaport town we were ever in,
where it is considered popular, or even respectable, to reside in
the immediate locality of the wharf, blacksmith shops, warehouses,
etc. It is certainly a bright prospect for the young bloods to
become sawdust aristocrats.

 WASHINGTON MILL CO. or WHAT'S IN A NAME---Was it the object of
the few ambitious men who formed themselves into an organization
and adopted the above borrowed name (which is reverenced by every
patriotic American), to carry out the principles that which the
great and good man advocated, or is it their purpose to seize upon
every available piece of land in the territory and thereby own and
control both morally and politically a state and people of their
own, thereby offering the greatest indignity in the name of Wash-
ington which could possibly be conceived by man?

Page 4

The Rebel Battery

Seabeck, W. T. October 1878

SEABECK ITEMS

Whol(e)yoke being such a noted rustler, we intend offering him the agency of this paper.

The Rebel Battery will be read all over the Pacific Coast, therefore it will be a good advertising medium.

In addition to other things we shall devote our self to reporting the _____ as practiced to the Washington Mill Co. for land grabbing.

We charge fifty cents a copy for the first issue of our paper, but after this we shall publish a regular monthly publication at $8.00 per year.

We do not expect to set Puget Sound on fire with The Rebel Battery, but we think that all the guns King Richard has in his kingdom well never silence it.

This paper will be sold at great discount to Rebels; the qualifications necessary to constitute a Rebel, being rebellious to all tyrannical despots and thieves under all circumstances.

Clayson says that he thinks he shall _____ at Port Townsend and spend considerable time in learning to talk Spanish fluently as he thinks this is about the only qualification _____ _____ at present to make a good _____.

It is rumored that the King is about to advocate the Throne, and that Hood's Canal is to become part and parcel of the Great American Republic, in which case the Rebel Battery will hoist the stars and stripes; fire a national salute; dismount the guns, and take part in the great celebration which must perceivably follow such a great an event.

FISHING IN SEABECK BAY---The Chinese fishing schooner having taken not less than twenty tons of fish of different kinds from the bay during the past year, their actions have attracted the attention of a number of white men who are calculating to build a fish weir and establish a fishing business at Seabeck. Look out for logs Richard!

Don't knock that fish-weir down!

THE SEABECK ROAD _____ AND HOW THEY ARE USED---Who dare ques-
tion for a moment the actions of King Richard in such a trifling
matter as this? Shall he not do as he pleases with his _____?
If he chooses to use the public funds for the purpose of cutting
a telegraph road from a portion of his Kingdom into the borders
of civilization, who dare to question his prerogatives? So once
is he the ____ of his ____ that such a trifling matter as this is
unworthy of is ____ ____ consideration.

LOOK OUT FOR THE NEXT ISSUE---In which well appear a minute
description of the different locations where the Washington Mill
Co. had teams of their own employed for a number of years steal-
ing lumber. We also have a list of names before us of men who
conferred their birth-right to the Washington Mill Co. upon about
the same terms as Esau did to Jacob, the company taking about the
same advantage of the poor devils as Jacob did Esau. We intend,
also, to publish a black list the names being taken from the books
of the Bay View Hotel with biological sketch of the individuals.

A Parable

And it came to pass in the days of King Holyonshus the 1st,
that a certain Claysonite did rebel against the King; and, be-
hold the King waxed wroth, and assembled his Chief dirt-eaters,
and the King spake unto them, saying: Lo! For these many years
have I ruled my Kingdom in peace from my stronghold in Seabeck to
the utmost corners of Hood's Canal, and behold I will smite the
Claysonite and with my large feet will I stamp him out of exis-
tence. Thus sayeth King Holyonshus and it came to pass on a cer-
tain day that the King did appear on the borders of his frontier,
even to the headwaters thereof, and he arose in great majesty to
his full height and beheld with amazement the preparations being
made upon rebel territory for a long siege outside the borders of
his Kingdom, and so the King retired in silence, with a troubled
spirit, into the heart of his stronghold.

Notice to Teamsters---The most powerful yoke on Hood's Canal is
Wholeyoke. Yes, good men, he is a whole team. Just in the one
capacity of yarding out for the W. M. Co., he is equal to five yokes;
he is also a postmaster, road supervisor, school clerk, treasurer
and band master, which is equal to about four yokes more. So eager

is he to snatch every dollar that he will seize upon everything in sight except ringshakers and lard butts.

A lady arrived in Seabeck the other day, and sent out her posters announcing that she would lecture on certain interesting subjects at the hall, charging the very small sum of twenty-five cents admission. After being in town a few hours, she must have ascertained the deplorable financial condition of affairs, as we noticed she scratched out the twenty-five cents, and sympathized with the poor, moneyless subjects by giving them a lecture.

It is rumored on the street that the little joker and his big brother-in-law calculate to buy out the Washington Mill Co. shortly, if everything goes favorable to their individual interests. Later---Since the above was put in type it appears that it is a false rumor, as we learn that it is only a half interest which they anticipate buying.

End of the paper.

Edward Clayson's assessment as to his standing in Seabeck might be described as a tad bit egotistical. The best example of why I say this is presented in his newspaper.

As a person reads his newspaper it becomes very evident that it's full of bitterness about the town being company run. There are several stories as to the run-ins that he had with the mill.

One of the important aspects when it comes to living in a remote area is the coming of the mail. It is the one thing that keeps someone in touch with the rest of the world. Early on Marshall Blinn was the postmaster. In 1868 he was officially appointed as Seabeck Postmaster by the U. S. Postal authorities at Washington, D. C. At that time the stamps were initialed by the post master to cancel them. That year the contract for carrying the mail between Port Gamble and Seabeck was put up for bidding. According to Edward Clayson, only three persons bid on the contract to carry the mail: John Connick, Jasper Baker and himself. His bid was $25.00 per year less than the other two so he was awarded the contract for two years. John Condon and old Joe Kinnear were the bondsmen. The contract signing was in the witness of Steve Hovey who was the postmaster at Port Gamble.

At that time Edward Clayson moved from Port Gamble to Seabeck because the way the delivery was set up he had to start from Seabeck at 8:00 am and be in Port Gamble at 4:00pm. The route ended on Friday back at Seabeck at 6:00pm.

The following is a list of postmasters at Seabeck:

Woodbury Sinclair, Marshall Blinn, Charles Cass, Edgar Vrooman, Richard Holyoke, Arnot Dickins, Nellie Howard, Harry Clarke, Walter Mac Farlane, Albert Hotchkin Sr., George Johnson, Frederick

Prosch, Helen Prosch, Jacob Krom, frank Blakefield, Albert Hotchkin Jr., Irene Hotchkin, Marie Halverson, and Harold Althof.

Harold Althof served from October 1, 1937 until January 12, 1968.

About the early 1870's the small sloops began to fade and the small steamers took over moving people and goods around the Puget Sound. These small steamers make up what was known as the "Mosquito Fleet". Some of them being of shallow draft could dart into places where larger boats couldn't. They would stop any place they could get into. In many cases they would get close enough to the shore, that whoever hailed them could wade out to the boat. A lot of unscheduled stops were made along a boats regular run. In some cases a pile of rocks were piled out into the water so a person could walk out to the boat without wading in the water. One such place was at Maple Beach. Other ways of getting out to the steamer was to have someone row them out in a small boat.

Along Hood's Canal a lot of these stops eventually turned into communities. Places like Holly and Nellita built docks to accommodate the small ferries. At one time Nellita was a resort with a hotel and a Post Office and listed on world maps.

Chapter Seven

Since starting on my research in regards to the Seabeck Cemetery and the restoration. I have been asked many times about local cemeteries. Sometimes families buried their own on their own property. Holly has a community cemetery as does Seabeck. There is also a small private cemetery on the old Henry Bruemmer ranch between Holly and Dewatto with about 24 burials.

As I searched for the names, it became apparent that many markers had been taken or damaged over the years. A newspaper article in the 1940's stated that the University of Washington had removed several of the markers and taken them to the university. For what reason they took them I do not know. I do know that when they removed the markers they did not note who was buried at that site.

Later, in 1956, a small edifice was built at the cemetery to protect what was left of the wooden markers. Two unfortunate things happened. One, they did not note the grave sites, and two, the building that was built to protect them was vandalized and the markers stolen. The edifice was built as a memorial to a Mirl Thompson. Since it was built before I frequented the cemetery, I know nothing about that person. Above all, I feel the intentions were most admirable. Although the wood rotted and the edifice became a hazard and had to be torn down before it fell on someone, I felt that the memorial plaque should be saved.

One of the questions that I'm most often asked is how I acquired the names. This was done several different ways. Newspaper obituaries were one source. When word was spread around that I was seeking information of persons buried there, several old timers came to the ceme-

tery and told me some of the names and stories about them. I felt very fortunate that back in the early 1970's there were enough old timers still alive that took an interest in what I was doing and assisted me as much as they did. Another source was the local funeral homes. They gave me access to their records. Lewis Funeral Home had been in business since 1909 and had fantastic records. Their records were volumes and volumes. As related earlier, when we discussed the task ahead of me, Lester Lewis Jr. suggested that I come after hours to keep from interfering with their operation and also it would be quiet for me to do what I wanted to do. So, for two weeks I showed up at the funeral home as they were closing and they locked me inside (figure of speech as it meant that others were locked out so I wouldn't be bothered). Those two weeks were painstakingly spent looking at every funeral they had performed since they began operations. Each page listed where the person was interred. At the same time I noted the names of persons buried at Brownsville because I was living there across the street from that small cemetery). In some cases the person's address was Seabeck, Crosby, Hintzville, or Camp Union and the person was cremated and the ashes were picked up by a family member. In those cases the name went on my possibility list of persons buried at Seabeck. Later I was able to establish that the ashes of some were buried in the Seabeck Cemetery.

Another source was the diaries of Jacob Hauptly who was Justice of the Peace at Seabeck. Mr. Hauptly kept a very concise diary. In his diary he entered many of the deaths at Seabeck from 1870 to 1886 the year when the mills at Seabeck burned.

One day when I was working on the cemetery an older woman (I was only in my twenties at that time) showed up with a notebook about her family. She was able to give me another 17 names and also was able to point out where they were buried. Rudy Hintz was another person that gave me much information. Eddie Zuber showed up one day and gave

me the name of Andrew Cichey and the story of his death. Joe Rostad showed me the three Rostad grave sites and their history. I attended the funeral of Nathanial Sargent (the only African-American) in 1954. A man named Herb Walton gave me the information on the Nickel's family. Bergie Berg was another source of much information as to burials. One day I received a letter in the mail from Ensley Doncaster Jr. His father was one of the ship builders at Seabeck. He gave me information of the Bowkers and Bakers. Other sources of information were the University of Washington, Washington State Museum in Tacoma, and the records in the Kitsap County Auditor's Office. I can't begin to tell you how much time I spent on my research to make sure my information was accurate.

In Edward Clayson's "Narratives of Puget Sound", the last narrative is an amusing story about a joke that Henry Shaffer (Henry is buried in the Seabeck Cemetery after dying in Seattle.) pulled on Old Anderson from Happy Valley (Holly).

I should mention that in Edward's narratives, he liked to show off how much Chinook Jargon he knew. After moving to Seattle, he always greeted people in Chinook Jargon.

The following is the Narrative No. 28 as printed in Edward Clayson's "Historical Narratives" titled:

"Marriage of Old Anderson"

We do not call to mind a single settler now left on Hood's canal who was there when Old Anderson first went there.

"Ahn-cut-ty Tillicums kopet Alta; Kona-a-way Mem-a-loose (old friends finished now; all dead). As near as we can remember, the tradition of Old Anderson is: He came to Port Gamble some fifty years ago in a Holland ship as a sailor, and located upon the very spot where he died. He could not speak a word of English when he left the ship, so he learned English and Chinook together; this being the case, he did not know when he was talking whether it was English or Chinook he was speaking; so when he had any dealing with anyone he would speak partly in English and partly in Chinook;

this condition left the old fellow at times in a very embarrass-
ing position. His place was always known as "Happy Valley," where
he lived in content with his faithful old squaw all these years,
getting his living entirely from the soil, and some little fishing
occasionally. He led a simple, comfortable life, never working for
anyone else. The more ambitious of his neighbors might envy him
his peaceable, easy life. His poor old squaw, now left alone, if
alive, is no doubt "sick tum tum" (sad heart).

The most eventful incident in the life of Old Anderson and his
squaw was some forty years ago, when the Indian Department issued
an order for all the squaws to be taken from the white men and
placed upon the Indian Reservations unless the white men married
them. (To the credit of the white men be it said that I do not
remember a single one of them who turned his squaw off.) Old An-
derson was one of the first to respond to the order of marriage, and
the old squaw was in high glee. "Yaka-kah-kwa Boston Kloochman;
yaka tenas Tyee Alta" (she now like the American woman; Chief now).

So Anderson launched his canoe and hurried down to Seabeck, about
twelve or fourteen miles distant, for the purpose of getting a
"marriage license." Now, Harry (Henry) Schafer, full of good na-
tured mischief, as he always was, was tending bar for Denny How-
ard at that time, and Old Anderson confided his "quiet mission" to
the humorous barkeeper and requested him to get him the required
"marriage license." But no one in Seabeck was authorized to is-
sue marriage licenses; the county seat, at Port Madison, was the
only place where they could be obtained; but Old Anderson in his
ignorance did not know that, and the accommodating Harry, the bar-
keeper, did not propose to be stuck on such a small affair as that
of securing a "marriage license," so he dug up, out of an old dusty
cigar box from behind the bar, a last year's road tax receipt, and
wrapped it up in a piece of fancy tinsel paper taken from an old
I. X. bitters bottle, and handed it to Anderson as a marriage li-
cense, with that broad smile of his, which he could hardly control
from bursting into a fit of laughter. Old Anderson felt very grate-
ful towards Harry for his kindness, so he treated the house and
started off for home with the "documentary treasure" of his life.
He reached "Happy Valley" in due time, and the faithful old squaw
received him with smiles of satisfaction, as she was now to become
"kah-kwa Boston Kloochman (same as the American wife). The next
morning, bright and early, Old Anderson was up and dressed, and
his squaw donned her "ictas" (pieces) of red gown and petticoats.
The family carriage (best canoe) was launched and the "two hearts

that beat as one" labored hard at the paddles for eight long hours
to reach the Skokomish Reservation before dark, where Myron Eells,
the preacher, met them, and immediately preparations were made to
perform the marriage ceremony. The two "youthful lovers" stood
up before the altar with feeling of great expectancy, and Ander-
son went into his inside coat pocket for the "sacred authority"
and handed it to the minister. A smile came over the countenance
of the minister as he read the "road tax receipt." Of course the
marriage ceremony was suspended and the minister explained to the
would-be man and wife the "huge joke" practiced upon them. Old
Anderson was dumbfounded, and the squaw flew into a passion and
railed at her spouse in violent language, exclaiming, "Mika delate
pelton; mika hale cumtux; Nika delate halo pil-a-pie kopa mika
Il'la-he; hyack klat-a-wah, nika wake ticker nanech mika" (you big
fool; you don't understand. I will not return to your home; go
quick. I don't want to see you).

So Old Anderson, with a sick "tum tum" (sad heart), paddled his ca-
noe down the slough a distance of about three miles to Union City,
where he unburdened himself to that reliable counselor of Hood's
Canal, the Hon. John Mc Reavy. Old Anderson stayed all night at
The Rush House, and went on his lonesome journey down the Canal
the next day, reaching his lonesome cabin by the sea before the
sun had disappeared behind Mount Olympus.

In a period of about three weeks Old Anderson had secured the of-
ficial license by the assistance of Clayson at the Bay View, and
he went at once to the reservation and married his faithful old
squaw, who lived with him as a faithful "helpmate" until the day
of his death.

End of Narrative

One of the early surveys brought about one major change well worth
mentioning.

Marshall Blinn had set aside a five acre cemetery. A latter survey
showed that fifteen of the graves were not on the five acres. The graves
that were outside of the designated cemetery were to be moved onto
the graveyard. In 1877 Jacob Hauptly was hired to clear five acres.

Jacob Hauptly became the graveyard keeper and recorded in his diary many deaths.

Government Survey Crew on Hood's Canal
– Photo courtesy of Cecil Nance Collection

I realized as I walked through the cemetery that the markers that had something to say had been removed for various reasons. Some were outright stolen. They left messages like:

"A native of Maine. He was struck on the head by a bottle of whiskey and killed"

He drank too much strong liquor, and tried to walk the boom, fell into the bay and drowned"

"Killed in a feud"

"Killed in a brawl"

"Murdered"

"A native of Ireland"

"Earth was too cold for me"

The oldest known burial in the Seabeck Cemetery is Walter J. Williams who died in 1860.

In 1868 James Allen was killed in a dispute over a bottle of whiskey. Charles Young (Gassy Charlie) found James Allen's bottle of whiskey behind a stump and a fight ensued with Charlie killing James. Charles Young had been from Australia and after killing James, he was tried and sent to jail. After getting out of jail he returned to Seabeck briefly to look for the man that had testified against him. That man had moved to Canada. After a few days Charles Young left and was never seen again.

The following is an account of the incident as told by Edward Clayson of the death of James Allen.

Quote:

The first murderer on Hood's Canal during this period was Gassy Charley, a "Lag" from Australia. He murdered Jim Allen in the fall of 1868 at the Duggerbush. They were working in the woods for Tom Pierce at the time. Jim Allen had a bottle of whisky hid behind a stump in the woods for private use, to be used in a temperate way from time to time as he needed it, and Gassy Charley watched Jim Allen hide the bottle, and he stole it. This petty theft brought on an altercation between them, and Jim Allen was killed on the spot. (A rabid prohibitionist would make Gassy Charley a hero, instead of a murderer.) Bill Blair was working for Tom Pierce at the Duckabush at the time, and he was the principal witness in court against the murderer. The prisoner was convicted and sent to the penitentiary for fourteen years. He swore right there in court what he would do to Bill Blair when he came out of prison, and at the end of his term he came back to Seabeck and hung around for a few days, but Bill Blair had gone over to British Columbia several years before the convict's time was up, and Gassy Charley did not dare set foot in British Columbia, as he was a "ticket-of-leave man" from Australia, one of whom came from Melbourne to San Francisco in '49-50. The Vigilance Committee of San Francisco hanged some of them and drove the rest out of San Francisco. A

```
"ticket-of-leave man" from the convict establishments of Australia
and New Zealand at this period could go to any part of the world
except the British Colonies or the British Islands. So Bill Blair
was perfectly safe in British Columbia from the vengeance of Gassy
Charley. (His real name was Charles Young, if I remember right.)
```

End of Quote

In the early 1970's during one of my unemployed periods I decided to put some effort into cleaning up and restoring the Seabeck Cemetery. Some of the local people were against me doing this as they thought I was going to turn it into a modern cemetery.

The word was put out that I was going to ruin the local rural grave-yard. While working one day a group of misinformed environmental-ists (mostly late teens and early twenties in age) tried to do their best to hinder my efforts. Every time I moved to another area to remove the salal brush to locate graves, the group came and had a sit-down in my way. After a few hours of this harassment I called it a day.

At that time an older Seabeck citizen took up the cry to stop me. She made a huge deal out of me being unemployed and associating me strongly with my brother that was well known for his illegal actions. In other words she degraded me as much as she could. Many of the locals joined her. One day when I showed up to work all my tools had been stolen.

At that same time the ownership of the graveyard came into question. Quit Claim deeds were used to sell off parts of the original five acre cemetery.

I proceeded to research the background on the ownership. Some of the old timers had told me that Marshall Blinn had set aside five acres as a free public cemetery for the area. When Marshall Blinn left Seabeck he sold his holding to his brother Samuel. I was able to find a document where Samuel Blinn sold his holding to a J. R. Williamson. In that

transaction there was a five acre parcel listed separately from the rest that was not included in the transaction. It did not specifically say that the five acres were for a cemetery. I did find out that Samuel did not like Seabeck and sold his holdings and moved back to San Francisco. Fortunately, I was able to find a letter in which he writes as to how happy he was to be back in San Francisco where he could go for long buggy rides in the country.

Jacob Hauptly was hired to clear the grounds by a Cemetery Committee and he entered in his diary about the hiring of him to do the job. He in turn hired some help to assist with the project. He was instructed to burn the logs on the grounds, but became the graveyard keeper along with his other positions in Seabeck such as Justice of the Peace, boarding house operator, slaughter house/butcher shop owner, member of the brass band, and organizer of community functions.

Two Civil War veterans and two Spanish-American War Veterans are buried in the Seabeck Cemetery along with a WWII, and a Korean War Veteran.

There is one African/American buried in the cemetery. His name is Nathanial Sargent and was a much liked member of the Seabeck/Crosby community and he was welcomed into everyone's home at any time. An interesting story that was told to me by the Lewis family is as follows:

The Lewis' had members of their family visiting from the deep south once when Nathanial happened to stop by dropping off the mail that he had picked up at Seabeck for the Lewis'. It was diner time so Mrs. Lewis asked Nathanial to join them for dinner. When Mr. Sargent sat down at the table, one of the relatives stated that she would not sit at the same table as a Negro. Mrs. Lewis then told her, "You are perfectly welcome to sit in the kitchen and eat if you would like.

This is a good example of the way people around the community felt. It was often said that Nathanial Sargent was the whitest man in Crosby.

The two Civil War Veterans are Ashbel Hite and Dempsey Wilson who lived at Hite's Center. The veterans of the Spanish-American War are William Johnson and Andrew Cichey. The Johnson family lived at Camp Union. The WWII veteran is William B. Brown, and the Korean War veteran is Melvin E. Just.

There are approximately 200 persons buried in the Seabeck Cemetery. Only 164 of the names are known. In the back of the book you will find a list of the names and dates of the persons that are known to be interred there.

I was told on several occasions that there was an Indian Burial Ground near the Seabeck Cemetery. At one time I had archeologists from the University of Washington come to Seabeck and try to help me establish whether this was a fact or not. They were not able to find any evidence that there had been a burial ground near there. I am inclined to believe that one did not exist near the Seabeck Cemetery because as a general rule the local Indians buried their dead near the water. Another fact is that prior to 1878 local Indians wrapped their dead in mats and placed their dead in canoes and covered the body with another canoe and elevated them into trees. Some time they were placed on an elevated frame. The person's valuables were buried with the deceased. The Seabeck Cemetery is much further from the water than one would expect to find an Indian Burial Ground. The first white man style Indian burial was in August of the year 1878 on the Skokomish Reservation. At that time the body was placed in a container and buried.

When Jacob Hauptly was clearing the grounds for the cemetery he made the following notation in his diary:

"I helped Green kill 1 bullock and 2 sheep in forenoon. Made a discovery in the woods near Grave Yard. I burned some of the logs outside burying ground fence. A little shower this evening."

This was on Saturday June 16th, 1877. As to his discovery he never did reveal what it was.

Seabeck burned in August of 1886 and the number of families dropped down to about 15. The property the town occupied became the property of Dr. Kendrick and the area south of the town was J. R. Williamson. In 1914 the J. Colman Company in Seattle bought the town tract from Dr. Kendrick and other lands from J. R. Williamson and others. The Colmans' restored many of the old original buildings and started a retreat for the YMCA. In 1948 the Colman Company dissolved and sold most of its holdings at Seabeck. It retained 90 acres for a religious retreat and the five acre cemetery. Walter Wyckoff was given the rights to liquidate the surrounding properties. In the document giving Wyckoff the right to sell the properties it stated that the five acres for the cemetery were not included in the transaction. Walter Wyckoff in the 1950's commenced to break up the five acre cemetery and sell the land by way of Quit Claim Deeds.

When I started to restore the cemetery, Kenneth Colman (one of the original purchasers in 1914) agreed with me that it should be restored and its history preserved for future generations. In all of our correspondence and conversations it was never anything other than a five acre cemetery.

Unfortunately, Mr. Colman died and I had to go back to work to support my family. It seemed that the protesters had won their battle for the time being as our work came to a stop.

The cemetery continued to deteriorate for the next thirty-years. When I had the chance I would do research on the ownership and learn what I could about the people buried there.

In 2007 I retired and had time to devote to the cemetery, and again took up the challenge of getting the cemetery restored. The new Director of the Seabeck Christian Conference Center (Chuck Kraining) was fully supportive of my efforts. Although they had a Quit Claim Deed giving them ownership, they really did not want to be in the cemetery business. My goal was to put the ownership into the hands of the Seabeck Community Club and have the cemetery placed on the National Historic Register. The Seabeck Community Club did not want the responsibility of taking over the cemetery. The reason was that they did not want to be involved with the Central Kitsap School District who had acquired two and a half acres of the original cemetery from the Wyckoff family who did not have the legal right to sell it. The question of ownership was left up to me. I engaged a lawyer to help me fight the district. It was very clear to me and the lawyer that the district did not legally own the land on the cemetery that they claimed.

I also had another goal. Clean up and restore the cemetery to its formal recognition as a cemetery instead of an area grown over by salal brush with garbage lying around.

In March of 2011 my wife Eloise and I commenced to remove the salal brush from the one plus acres that held graves. It was painstakingly slow as each piece of brush had to be cut individually. The reason was that by only removing the brush I would be able to visually locate some grave sites. In the process we located other markers under the brush. It took us five months to do half of the cemetery. I posted a request on the bulletin board at the Seabeck Store one time for volunteers to help us, but only one person (Jay Jasper) showed up and he gave us a good two hours of work. A month later Mr. and Mrs. Abrahamson showed up and helped us for two days giving us three hours of work. We thank them very much for their help. Another time 12 teenagers who were staying at the Conference Center came up and helped us. The following is a list of those 12 remarkable kids and where they were from: Phillip

Olson, Althea Dillon/Hood River, Oregon, Alison Sturrock/Vancouver, British Columbia, Mc Kema Niemer/Seattle, Washington, Quinn Mc Cray/Vancouver, Washington, Sonrisa Alter/Portland, Oregon, Lena Easton-Calabria/Seattle, Washington, Celia Easton-Keehler/Portland, Oregon, Tara Fussell/Issaquah, Washington, Maddy Barett/Bend, Oregon, Grace Jones/Seattle, Washington, Rose Boughton/Seattle, Washington, Michael Elliot/Portland, Oregon, James Waugh/Portland, Oregon, Robert Bermon/Vancouver, Washington, Michael Valbuena/Vancouver, Washington.

It should be noted that none of these kids lived in Kitsap County, but were willing to give some of their vacation time to participate in a worthwhile project.

Back in the 1970's I had made a chart showing where graves were located. After removing the brush we realized that I had missed some of the sites. This prompted a more up to date map and also more accurate description of the cemetery. The updated plat map is now stored at the Seabeck Christian Conference Center.

Ellen Ames: was the wife of Raleigh Ames. They are buried just south of the Russell plot which is on the south side of the Hintz plot. Before she died she had been ill for some time. The eve of the night she died she felt like she wasn't sick anymore and attended the Crosby dance. It was a Saturday evening. She danced and enjoyed herself like nothing was wrong. That night she died in her sleep. Her husband didn't even know she had died until he got up that morning.

Raleigh Ames: He lived with his wife about a half mile south of where the post office is now. With his wife and kids they moved here from Pocatello, Idaho arriving in 1940. He went to work in the Navy Yard in Bremerton in the sail loft. Raleigh had been married previously and had two children by that union (Raleigh of Lewiston, Idaho and Mary Stinger of Pocatello, Idaho. Upon his second marriage there was pro-

duced four more children: Roulon (Bud), Theon, Mona, and Calvin. He was known as Pop Ames and he drove the school bus from Holly to the Seabeck Elementary School in the early 1950's. His wife Ellen always rode with him setting in the seat in back of him always knitting. When they first arrived in Crosby they lived in a log house in a field by the Crosby School for two years and then purchased a house three miles south of Seabeck.

Chapter Eight

There were several Preachers that called on Seabeck and other communities on Hood's Canal. The following is a list of some of them: Myron Eells, Rev. J. T. Huff, Rev. Lane, and Rev. Dave Sires who was murdered by a man named Payson, Rev. Taylor, Rev. Wirth (Hauptly's spelling) Worth (Clayson's spelling), Father Prefontain, Rev. E. P. Hyland, Rev. Cranberry Carins, and Mr. Wisker.

Just a little side note here as to what Jacob Hauptly said about Rev. Mr. Wisker. Quote: "The shortest and homeliest white man I have ever seen in Washington Territory."

Edward Clayson described Mr. Wisker in his book as being treated with respect, but not with veneration. He could preach as good a sermon as any of them. His appeal was excellent, and impressive, but the "stupid stigma" exercised by fools, was always applied to him as having been a saloon keeper.

Possibly the first religious person to arrive on Hood's Canal to convert the local Indians was Father E. C. Chirouse, who was a Catholic priest. He arrived about 1850. The two tribes he had missions at were the Twana and the Kolseed bands. Father Chirouse had a lasting impression on the Indians. The Skokomish and other tribes held a council and convinced him to leave. After he left it appeared that the Indians returned to their old ways. When the Protestants arrived the Indians tried to revert to the Catholic ways. This made it difficult for the Protestant teachers.

Between 1860 and 1871 there seemed that there was very little religious teachings. From time to time Rev. W. C. Chattin, a Methodist Episcopalian, and one Mr. D. B. Ward a protestant Methodist tried to teach school and Christianity.

In 1871 the Skokomish Agency was formed and given to the American Missionary Association. That same year Mr. Edwin Eells was nominated to be the Indian Agent for that agency, and was confirmed by the Senate. In May he took over the charge of the reservation.

Edwin and Myron Eells were the sons of Rev. Cushing Eells who went to the Spokane Indians as a missionary in 1838. After the Whitman Massacre it was deemed unsafe for him to stay in the area.

Edwin was born July, 1841, and Myron was born October 1843. Edwin had many talents having been a farmer, school teacher, and store clerk, teamster, and studied law. All of these talents served him as the Indian Agent. As soon as he could he started a Sabbath-school and prayer-meeting. He brought other Christians with him consisting of a physician, school teacher, and matron, carpenter, farmer, and blacksmith. In 1872 his father came to live with him and they both preached. That same year he brought Rev. J. Casto, M. D. who was employed as the government physician. Edwin's brother Myron joined them on June 22, 1874.

The Revered Myron Eells seemed to be the one religious man that called on Seabeck the most often. His wife's name was Sarah M. with her maiden name being Crosby. They lived where Twana State Park is now on what is called the South Shore between Belfair and Union City.

As Mr. Eells traveled around the hood's Canal area he was treated with much respect and kindness. When he was in Seabeck he was always invited to stay at Richard Holyoke's house without charge (It was customary for travelers to pay for their room and board when stay-

ing overnight). This was at least four different weeks of the year with many other occasions occurring in between.

Richard Holyoke's house – Photo courtesy of Seabeck Christian Conference Center

On several of the small steamers (The Colfax, The Gem, The Mc Naught, and the St. Patrick) he was given free passage along with his family and any Indians that were traveling with him.

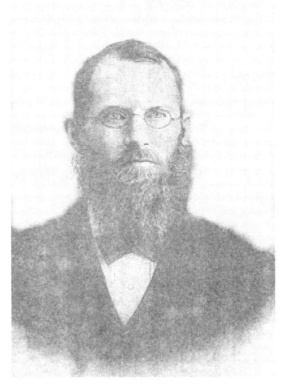

Reverend Myron Eells – Photo courtesy of Myron Eells grandson

In December of 1880 the women of Seabeck gave Mrs. Eells a box for Christmas containing over thirty dollars' worth of things. One of the items was a cloak which she had tried to make herself but lacked enough cloth to do so. She then used what cloth she had and made a cloak for their son.

It might be noted that Seabeck never had a structure built that was referred to as a church. Even during Seabeck's hay-days the church services were held in private homes or the mill's meeting house.

Medical facilities were non-existence in Seabeck until the middle of the 1870's. Prior to that there were accidents and deaths among the pop-

ulation. There is little doubt that some of the deaths could have been prevented had there been a doctor or medical facility available.

Medical assistance seemed to be available in Port Gamble and Port Townsend, but that was several miles away and time was probably a factor in some of the accidents and deaths.

In 1877, Dr. F. P. Kendrick started up practicing medicine in Seabeck. Prior to that, no medical aid was immediately available. If there was an accident a doctor had to be summoned or the person transported to a place where medical attention could be administered. According to purchase invoices in the Washington Mill Records, there were plenty of medicines available in the company store.

That same year (1877) telegraph came to Seabeck which made communications to the San Francisco area faster than by ship. Electricity followed in 1883 making the area more modern and able to keep up with Seattle, Olympia, and Tacoma.

Warren Lewis Clough came to the area in the 1870's and was a game warden for a couple of years. He homesteaded between Crosby and Mission Lake.

Chapter Nine

The area known as Crosby encompasses several communities. After Seabeck became established a trail developed between Seabeck and Oakland (Shelton) in Mason County. This trail started at Seabeck, went up what is now Larson Lane coming out at the present day Camp Union. From Camp Union the trail then traveled up the west side of Big Beef along Peter Hagen Road and part of Lewis Road, crossing over to what is now Gold Creek Road, continuing south between Mission/Tiger Lakes and Panther Lake, then on down to the head of the canal. From present day Belfair it crossed over to Allen, then on down to Oakland.

This is the route Jacob Hauptly used when bringing his cattle to Seabeck. As Seabeck grew and more people spilled out away from it, it was natural to settle along existing roads and trails. Jacob filed a claim on Section Seven which is just south of what is now the junction of Holly Road and the Seabeck-Holly Road. He built a ranch at that location to hold the cattle he purchased from down south. Following the trail going south next was Alfred Turner, T. J. Lewis, Frank Rensch, Nathanial J. Sargent, Cloughs, and Curtis. These folks turned the trail into a good road enough to drive a horse and buggy on.

To the west of the trail the Zubers along with, Morgan (Morgan's Marsh), Zoffels, Nelsons, Qualhiems, Christensens, Hagans, Bassets, Hintzes and others. At the same time others were moving into the area such as the Hites, Wilsons, Fenwicks, and the Coates. The biggest influx of families came to Crosby when the Westfork Logging Company owned by Tom Murray, set up operations at Camp Union (1921).

In June of 1954, E. E. Riddell made an attempt to record the history of some of the communities around the county. He interviewed many of the local citizens and recorded what was related to the communities' history. He then typed up the information given to him, and the passed out copies to people in that community. He following is from the copy he gave to my grandmother (Nancy M. Just). Unfortunately he obtained some inaccurate information.

As far as the information of Crosby and the surrounding area, I find he did a pretty fair job with what he wrote down. I don't blame him for the errors as he was misinformed. What he wrote is of great local historical value, so I will reprint what he wrote with corrections made where he was wrong.

Events in the History of Crosby

Written by E. E. Riddell

June 1954

In 1881 Mr. and Mrs. Thomas J. Lewis arrived in Port Townsend, having been aboard the Olympus, a sailing boat which was sailing from San Francisco. She caught fire and burned to the water's edge. The passengers took to the life boats and were picked up by the sailing boat "Warhawk" (which itself burned later in Discovery Bay), which took them to Port Townsend. The Olympus was carrying oakum and gun powder at the time she caught fire.

Mr. and Mrs. Lewis lived at Port Townsend and Port Gamble for a short time before coming to Crosby where they took up a homestead in Sections 13 and 18, and proved up on the land receiving a U. S. Patent dated July 3, 1890.

Other settlers came during the 1880's and took up land in the beautiful little valley west of the Blue Hills. Mr. and Mrs. Ash Hite and family of 3 sons and 2 daughters homesteaded about 1886. Mr. Hite was a Civil War veteran. They pioneered for a while then moved to Seattle, where they were at the time of the big Seattle fire on June 6, 1889.

His daughter Sadie, now Mrs. Fenwick, remembers that her mother and father made coffee and carried it to the firemen who were fighting the famous fire.

The Hite family moved back to Crosby in 1909, and the two daughters, who are now Mrs. Sadie Fenwick and Mrs. Icia Spencer, still live here, also their brother George.

Mr. and Mrs. James Graham started the first post office in 1891, and he was appointed the first postmaster on Oct. 3, 1891. It was located about a mile south of the school house which we are in tonight just south of the Lewis property.

Mrs. Graham named the town Crosby after a town in England where she had lived.

Mr. Graham was postmaster until September 9, 1895, when Henry C. Mc Lean was appointed in his place, but was acting postmaster only one month when the post office was discontinued on October 5, 1895, and every one had to go to Seabeck for their mail.

On September 1, 1905 the post office was re-established with Mrs. Jessie Guptill as postmaster. She continued as such until March 17, 1913, when Marian A. Hoenshell was appointed postmaster, and the office continued as such until Apr. 15, 1918 when it was discontinued again.

When the post office was first established a Mr. Berry carried the mail from Seabeck on horseback three times a week. He also carried the

mail by horse back from Olympia to Seabeck over the old Territorial Trail.

Mrs. James Graham had been told by a fortune teller that she would die by being crushed, and she always had a fear of such happening, and had all the large trees cut down, surrounding her home. Later she and her husband moved to British Columbia, where they lived for some time, when a mountain near their house slid down and buried the house crushing Mrs. Graham.

Other early settlers and homesteaders were N. J. Sargent, a Negro who was highly respected in the community.

R. O. Qualheim had a homestead at Crosby, and later moved just west of Bremerton, where a particularly steep hill is still known as Qualheim's Hill. Mr. Qualheim is well up in years and now resides in Bremerton.

Paul Myhre, Mr. and Mrs. Jacob Zuber, H. P. Fraser, Mr. and Mrs. Gill, James Weeks, Thomas Craft, Charles Gardner, John H. Barnes, were all early homesteaders.

Andrew Nelson took up a homestead where the present school house is located.

A Mr. Fell of San Francisco, who was a writer for the San Francisco Examiner, came to this part of the country to get information for articles to be published in the Examiner. He fell in love with the country and took up a homestead.

Al and George Turner were among others to homestead, and later sold to Henry Bode, a tailor in Bremerton. They had set out 2000 fruit trees, mostly prunes.

Louis Clough took up a homestead near Tahuya Lake, and was known as an expert trapper, and in the early days there were plenty of wild animals to be had.

William A. Butler and wife were among early homesteaders, and were known as the first couple to be married in Seattle after the Territory became Washington State.

A Mr. Boyce built a log house in 1893 near the old Post Office. The log house is still standing. He planted birch trees which he brought from Kinnear Park in Seattle, and many of them are still growing.

The first school house was built in 1891 by the combined efforts of George Stevens, Ash Hite, Tom Lewis and Jake Zuber. This first building later became the teacher's cottage and is near the present school building which was erected in 1923. (The cottage burned February 5, 1976).

The first school teacher was Harry Zeek, and he was followed by Helen Tolo, who rode horse back from where she lived to the school house. John Dixon was the third teacher. Fred Ceise, Albert Peak, Nellie Veldee, and the well know teacher, George Cady Johnson, and Miss Margaret Whittle were among others who taught.

Miss Henrietta Bucklin, now Mrs. W. O. Lewis, taught school here in 1908-09. She roomed and boarded at the home of Mr. and Mrs. John Shekles for $12.00 per month. Mr. Shekles was one of the school directors. She also stayed at the home of Mr. and Mrs. Weymour Guptill.

School in those days consisted of a term of three months.

Andrew Cichey homesteaded here in the early days and continued to live here until 1934 when a band of gypsies beat him up and robbed him by the Seabeck store. He died from the effects of the beating.

Julius Hintz was one of the early homesteaders, and in later years this part of Crosby became known as Hintzville.

H. P. Fraser homesteaded in 1886 and later had a store in Seabeck.

Frank Drumml bought the property in 1919.

Mr. and Mrs. Henry Olaine were among the early settlers, and William Burns took up a homestead where Camp Union was later located.

William Counter had a homestead near Tahuya Lake, and Rudolph Zoffel was also an early settler. Henry Sacher had forty acres in gooseberries, which he sold in Seattle, taking them by boat from Seabeck. Other farm produce such as eggs and butter were shipped to Seattle by boat from Seabeck, until the automobile became into general use, when produce was taken to Bremerton.

Clark's lake which was situated in a swampy part of the surrounding land was nearly a mile long and half a mile wide. Later this lake was drained and the sectional lots assessed as full forties. It was a favorite place for beavers, and they have now increased in number and have dammed up the outlet and the lake is gradually filling up again.

Wild cranberries grow in the swampland around Morgan's Marsh and the early settlers gathered them each year.

Jacob Hauptly was one of the first settlers. He came from Switzerland when he was a small boy. When he was 18 he left Illinois for the California gold rush. He left California settling at Brinnon in 1858, later moving to Seabeck and took up a homestead at Crosby. He raised beef cattle on his homestead and bought and sold cattle from all over the country. Cattle were driven in from Chehalis and Elma over the old Territorial Trail. He had a slaughter house and butcher shop in Seabeck. While in Elma he met his future wife, Louise Reid of Elma. They were married and continued to live at Seabeck where three of their children were born. In 1886 they moved to the Webb Ranch

near Union and later had charge of the Puget Mill Company's ranch at Clifton (now Belfair). He was postmaster at Union City. One of the letters in the files of the Puget Mill Company written by R. Amos after the Cleveland administration, recommending various persons for post masters under the Republican administration and asking that one Jacob Hauptly be retained as Postmaster at Union City, states: "In spite of the fact that he is a Democrat we believe him to be honest".

Mr. Hauptly was a very methodical man and kept a daily diary which would be of inestimable value now, but unfortunately several years of it was burned up. His son Cleve lost his life in the burning house at Union, trying to save the diaries.

A tin mine was started in 1891. The miner did considerable work, having driven a shaft into solid rock about 70 feet another shaft straight down for 150 feet. The mine never proved to be very successful. Tin Mine Lake is now called Scout Lake.

A gold mine was also filed on about 1890, and the original claim papers were posted under glass on a tree, and were known to be there in 1907. Considerable work was done. A shaft was driven into the mountain for 775 feet. Railroad rails and car are still in the shaft. The amount of gold taken out was small and when the Alaska gold rush came in 1898, the mine was abandoned and the owner, a Mr. Noah went to Alaska to seek his fortune.

A fire lookout station was built on the top of Green Mountain in the early 1920's when the Mc Cormick Logging Co. built a road into Green Mountain. Later the tower was rebuilt considerably higher and a fire lookout station is still maintained there. (Authors note: In the 1960's the guy wires that held the lookout steady were vandalized and the lookout tower collapsed.)

The C. C. boys opened up forest protection roads using the old railroad right of ways.

William Burns took up a homestead where Camp Union was located.
Up until 1921 there was not a great deal of logging at Crosby until Tom
Murray, of West Fork logging Co., established Camp Union, where he
built repair shops, a round house and store for logging operations. He
built a railroad to Seabeck where the logs were dumped. Later Camp
Union was taken over by the Chas. R. Mc Cormick Logging Co. of
Delaware, which extended operations until they had 86 miles of rail-
road track, with 4 locomotives, donkey engines and all the necessary
paraphernalia for extensive logging operations.

They took out 1,500,000 feet of lumber per day. This undertaking end-
ed in 1936 when the camp was abandoned.

There has been some logging on a small scale ever since.

Crosby community has always been organization minded. In 1911 they
formed the Crosby Community Club and incorporated. Julius Hintz,
Edgar Corson, Sid Wilson, Jacob Zuber, T. J. Lewis were the early
leaders. Everyone in the community helped build a hall, even the young
men who were away working sent money home to help buy material.

At some time the following organizations have been active in the
community: Red Cross, Parent Teachers Association, 4-H clubs, Girl
Scouts, Boy Scouts and a ladies Auxiliary. The Auxiliary hold Ba-
zaars every fall, and at one time raised $580.00. This Auxiliary is
now the Home Makers Club and as such is a part of the county wide
organization.

Church was usually held in the school house. In the early days Rev.
Myron Eells, who was a Missionary on the Skokomish Indian Res-
ervation, came by horse back to Crosby to hold church services. He
performed several marriages in the Lewis home and christened many
babies in the community.

In later years Rev. S. J. Bassett and wife came from Wales, England and took up a homestead and held church services in the school house. Later he wrote news items for the Poulsbo Herald.

In 1944 a church was built under the auspices of the Assembly of God, and recently was sold and is now known as the Mission Covenant Community Church.

Thomas J. Lewis built a saw mill on his homestead in 1906. Mr. Lewis was a millwright by trade.

In the early days the term of school was three months each year, but the children of Crosby and Mission Lake managed to receive six months schooling each year, by reason of the schools holding their sessions at different times. The children of Crosby would go to Mission Lake and board there for three months, while attending school, and returning to their own school when opened. The children of Mission Lake would go to Crosby when their school was not in session.

Some of the early school directors were A. J. Coates, Julius Hintz, Lester Clough, and since 1939 Mrs. Elsie Christopher has been on the school board continuously, both for the local school district and later for the consolidated high school district.

Nellita, Crosby and Mission Lake school districts consolidated in 1910 for financial reasons, but each community had their separate school until 1918 when Mission Lake children were transported to Crosby by truck.

Crosby Grange was organized in 1910 and continued to operate until 1922 when it disbanded.

One of the first automobiles to appear in Crosby was at the home of Frank Rensch.

Chas. Brumm and wife moved onto the old Lewis property and lived there for many years, raising a large family.

During the depression years many people of the community made a living by picking huckleberries, and huckleberry brush, cascara bark and selling same. In later years the brush picking business became quite an industry, when Callison's of Port Orchard and others bought and shipped the evergreens to all parts of the United States.

Wherever you find ladies you will find flower gardens, and the ladies of Crosby from the early days to the present have had lovely flowers such as honeysuckle, roses, daffodils, and all the old favorites.

When Mrs. Sadie Fenwick lived in Seattle, she took voice lessons, and when her family returned here, she was known for her beautiful singing at numerous entertainments.

Among other talented women of Crosby, were Emily Ebert, pianist, and Mrs. O. C. Palmatier, music teacher, also Mrs. Icia Spencer was a talented painter, and Reno Langstaff was well known for his photographs.

Mr. O. C. Palmatier was County Commissioner from 1912 to 1920.

Teresa Lewis, oldest daughter of Mr. and Mrs. T. J. Lewis was married on Aug. 6, 1906 in a large tent on the Lewis homestead by Rev. Myron Eells. The wedding was followed by a pot luck dinner with friends and neighbors coming from various surrounding towns. To top off the dinner, ice cream was served which had been shipped by boat from Seattle to Seabeck. Later in the evening everyone danced in the barn.

Among the young men who went to the First World War were Paul, Rudy, Emil Hintz and Francis Olaine.

A trip to Port Orchard, the County seat was quite an undertaking in the early days. They went by horse and wagon by way of Mission Lake and across Union River where the Barney White Road is now located and thence to where the Airport is now located, as there was no road around the bay to Port Orchard. This old wagon trail followed somewhat closely to the old Territorial Trail which went to Olympia.

The old pack peddler was a familiar figure as were the Watkins and Raleigh salesmen, who would stay all night at a farmer's home and pay for their lodging by trading some of his products.

When people became ill and a Doctor was called from Bremerton, he would rent a horse and buggy to drive to Crosby. On one such occasion Dr. Holmes drove out one stormy day and found a tree across the road. He left is horse and buggy and walked four miles to the home of Mr. Zuber.

Mattresses in the early days were made by cutting sweet grass that grew on the edge of the marsh.

Louis Clough's grandchildren, Mrs. William Houde and Mrs. Laura Hartz are still living in Crosby.

A civilian defense lookout station was built on top of the meeting/dance hall.

The first telephone was at Camp Union in 1923 and electric lights in 1925; however lights were not in general use until 1937.

There have been four generations of the Lewis family living here.

Life in the early days was rugged but enjoyed by all. No one thought anything of walking to Chico or Seabeck. Grandpa Warren Clough use to walk 8 miles to Seabeck, to save his horses.

Sometimes the dances were a little rough and coffee cups were thrown around like confetti.

Julius Hintz played the violin or flute for dances.

Rumor has it that Big Beef and Little Beef were so named because in the early days the residents wanted to build a bridge across the creeks, but the homesteader on Big Beef made such a protest or "Beef" about having a bridge built, that the creek became commonly known as Big Beef, and the owner on the

smaller creek made less of a protest and it was called Little Beef.

One can relax at Crosby just watching the colorful panorama of all seasons, the still snowy whiteness of the mountains in winter, the fragrance of spring with the woods full of beautiful rhododendrons in bloom, interspersed with the pure white dogwood against the pink back ground is worth traveling many miles to see. Then the green warmth of summer, followed by an almost unbelievable brilliance of color in the autumn.

The beauty of the mountains in the near distance, with the peacefulness of the valley snuggled at the foot of the Blue Hills, does something for one, as can be testified to by all those settlers who have hewed out their homes and live here through the years.

Paul Bunyan, the legendary lumberman who cut scores of tall trees in a day, or dug a canal when he wanted to go fishing, really had nothing on the early pioneer, for their collective efforts made it possible for them to make a living as those hardy pioneers of Crosby did by clearing the fertile land in this valley and raising their own gardens and selling what surplus they might have. Logging really didn't get started in this community until 1921.

In the early days the pioneer hitched up his horse team and slowly drove through the winding roads up to the head of a canyon and down the other side to visit a neighbor who might be grandma Hite or someone else equally as glad to have someone to talk to. She would get out

her best handmade table cloth and prized dishes and before you know it the table was groaning with delicious homemade foods of all kinds.

Yes, "There's Beauty every Place", written by Fred Toothaker express-es the reason why Jacob Hauptly, T. J. Lewis, Ash Hite, and all the other early settlers loved the Canal country:

```
There's beauty in the sunlight and
The Blue that's in the sky.
In stars that twinkle in the night
And in clouds in passing by.
There's beauty in the mountains high
And in the valleys deep.
Yes, even in the rain that falls
To bring the rainbow's sweep.
There's beauty in the foliage that
Abounds on verdant hills.
And in the fragrance and perfume
Of blooming daffodils.
There's beauty out beyond the west
In red of setting sun.
And in the silver gray of dawn
Disclosing day begun.
```

When E. E. Riddell wrote the forgoing he had asked the locals to gath-er and tell him what they knew about the local history.

As to whether Jacob Hauptly was the first to homestead in Crosby there is no proof, but he was surely one of the first. After he moved to Union City he tried to sell his ranch without much success. Eventually

(after 1900) he sold it to a Mr. Edward Corson who was one of the organizers of the Crosby Community Club in 1911.

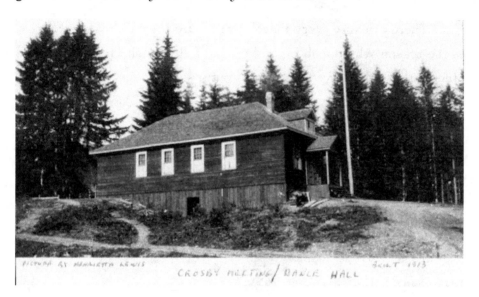

Photo out of author's collection

Alfred H. Turner homesteaded on the south side of Hauptly's property and lived there with his brother George. Turner later sold out to Henry Bode. My grandfather (Andrew Just) purchased the land from Henry Bode in 1921. The Turners planted nearly 200 fruit trees on their property. Most of the trees were prune trees and when I grew up on the property there was only one prune tree left. My grandfather purchased two hundred and fifty-two acres for $1,500.00.

My granddad Andrew Just came out to the northwest from Nebraska along with the Brumms and settled in Goldendale near Yakima. When my uncle Fred was killed in a logging accident here in 1921, granddad came to the funeral and liked the area so moved his family up here. The Brumms followed shortly thereafter. Edna Brumm attended Crosby School during the third grade at the age of 7 in 1927. William J. Brumm worked for the Mc Cormick Lumber Co. at Camp Union as a faller and bucker. He married Emma and they had three children named Bertha, Clara, and Marie. William also had the first store at

Lone Rock. Emma was a teacher who taught school at Lone Rock, Seabeck, Chico, Glenwood and Franklin. Charles F. Brumm was the brother of Emil and Frank. Charles was married to Lena Wackel in 1901. Emil Brumm worked at Camp Union for Charles R. Mc Cormick Lumber Co. in Jan., Feb., Apr., May, and Jun. of 1932 as a faller and bucker.

The Fenwicks lived at Hite's Center and was related to the Hites. William Fenwick is buried in the Seabeck Cemetery. Earl S. Fenwick was at one time president of the Crosby Community Club and his wife Sadie took singing lessons and sang for the people around the community.

R. O. Qualhiem and the Christensens homesteaded on the east side of Morgan's Marsh. Mr. Qualhiem migrated to Bremerton where he died. They intermarried and were also related to the Myhres.

Brithe and Niles Myhre are buried in the Seabeck Cemetery. He was born in 1829 and died in 1893. She was born in 1830 and died in 1894. The Myhres later moved to Silverdale. Members of their families still live in Kitsap County. Paul M. Myhre homesteaded between Crosby and Hintzville coming to the area in 1885 with his bother Peter. Paul signed a petition to build a road in 1909 from Holly to Gorst.

Thomas H. Craft and his wife Mary homesteaded in Crosby. He was born in 1855 and died in 1918. She was born in 1859 and died in 1915. Both are buried in the Seabeck Cemetery. He signed a petition to build a road from Gorst to Holly in 1909. He is mentioned in Hauptly's Diary on April 26, 1890.

The Clough family homesteaded half way between Crosby and Mission Lake. Warren Lewis Clough was born in 1847 in Salisbury, Connecticut, and was buried in the Seabeck cemetery when he died October 17, 1923. He signed a petition for the road from Gorst to the Holly-Dewatto road in 1909. His wife's name was Caroline. They had nine children: Jasper, Chester, Crogan, Jonathan, Lewis, Lester, Warren

B., Albert, and one other. Warren came to Crosby in 1888 and his wife joined him in 1889.

Albert Clough in front of his house in the 1890's
– Photo courtesy of the Houde Collection

Lewis Clough homesteaded halfway between Crosby and Mission Lake May 13, 1896. He came here at the same time as Warren Lewis Clough. Lewis was born in 1847 and died Oct. 7, 1923. His wife's name was Julia (Vaughan).

They had a son named Lester who was born in 1878 and married Mary Hinton who had been born in Oregon in 1882. They were married in 1908. He was a trapper and a game warden at one time.

Lewis and Julia Clough – Photo courtesy of the Houde Collection

A school house was built across from the Nathaniel J. Sargent homestead between Crosby and Mission Lake on a road that was called Cannon Road that went in back of the Rensch homestead. When the school was closed, Christian Rostad bought the building for $50.00. The fencing around the school was taken by Sam Basset. The land for the school was donated to the school district by Nathaniel J. Sargent.

The following are class photos from the Crosby School while it was open. All of the photos are from the author's files and acquired from Verne Cristopher and Vivian Just. Unfortunately the years were not written on the back or the names of the students and teachers.

From left Ella Fowler, Betty Davis (author's mother), and next to her is her sister
Phyllis.

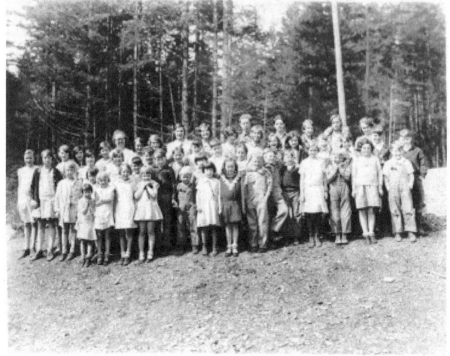

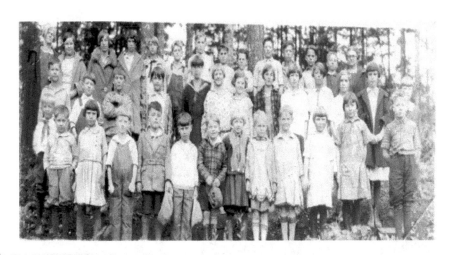

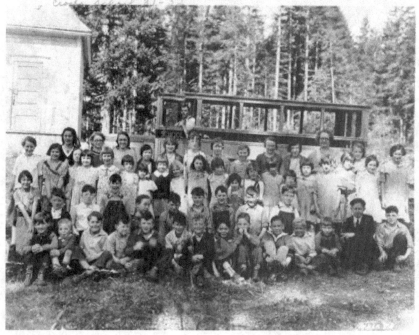

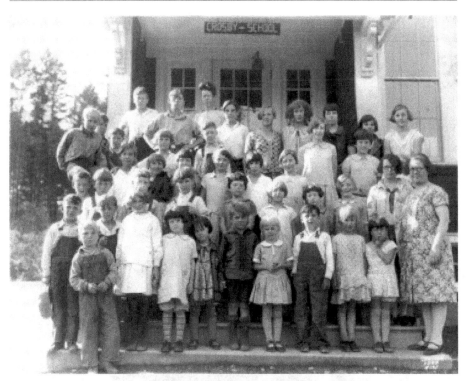

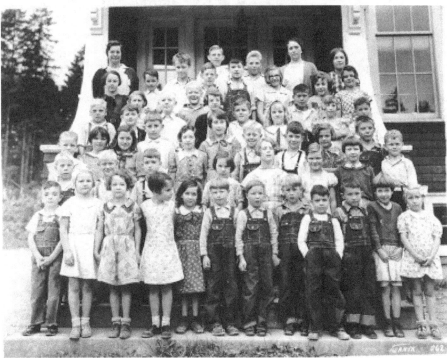

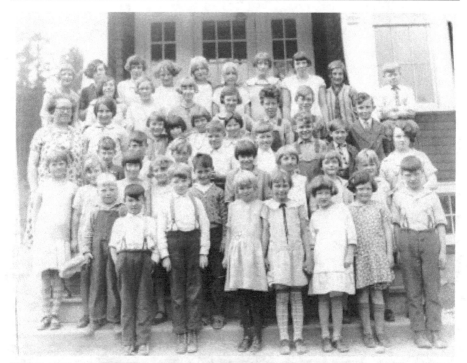

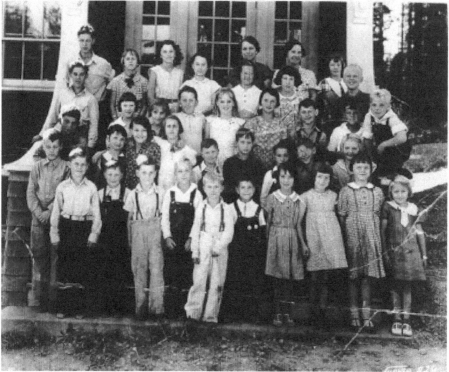

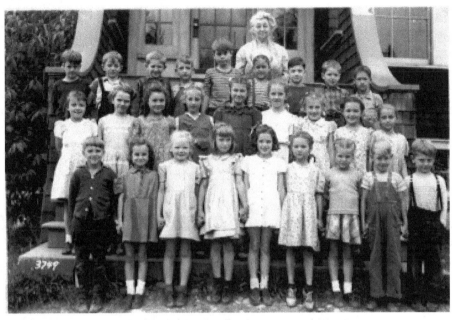

The above picture has the following students in it: Gloria Reed, Vivian Just – Viola Christopher, Ray Fowler, Ernie Just, and Dick Houde.

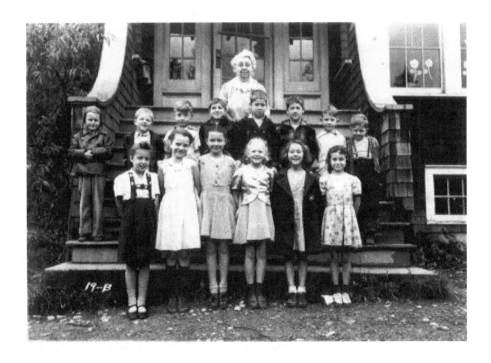

The following is a letter written to the Directors of Crosby School:

To directors of Crosby School:

I am hereby entering a complaint of the Nellita bus route:

First, that there should be heat on this bus as per school law. The children come home in a very chilled condition, and, I suppose, get to school the same way.

Next, the old bus is on hard tires and therefore the speed that is made on these roads is not only unsafe, but decidedly uncomfortable. The posted time schedule gives six minutes from Nellita to Hintzville, over three miles, or better than 30 mph. This speed, over this piece of road should not be over 15 mph at any time. The whole trip is made in less than 20 min.

Would like to call your attention to another thing. The primary grades are let out at about 2 o'clock and must wait until 3:30 for the bus. During this time they must stay outside, no matter what the weather. They are threatened to be punished if they enter the basement. Now, I believe that the basement was made for something beside the stove, and children who have sense enough to come in out of the rain should be allowed to do so. Therefore I suggest that, as Mrs. Carter is so easily annoyed, you should ask that the teachers and classes change rooms, leaving Mrs. Carter her peace of mind and the other teacher in charge of her pupils the full day. This change could be effected in a very short time, and with very little trouble.

 Respectfully yours,

 V. R. Davis

William (Pop) Fenwick is buried almost at the back of the cemetery. His biggest fear was that grave robbers would steal his body, so his casket is encased in concrete. He was born November 23, 1854 and died March 16, 1947.

The Crosby Community Hall doubled as a meeting place and a dance hall. Just about every Saturday night during the dance a fight would break out most of the time. A lot of the time it was between the loggers from Crosby area against the fishermen from Seabeck.

Mr. and Mrs. Albert Phunt use to walk from Holly to Crosby on Saturday evenings just to dance and someone would give them a ride home afterward. One night in particular a free for all fight broke out between the loggers and fishermen in the middle of the dance floor. The band kept playing and Mr. and Mrs. Phunt kept dancing dodging in and out between the fighters that were having a knock down bloody battle. As to who won the fight, I don't remember as I was pretty small when that incident happened.

During the Second World War a lookout structure was built on top of the dance hall. This was manned to watch for enemy aircraft.

After the dance hall/meeting building was torn down, dances were moved to the old two-room school house. Eventually the weekly dances came to an end.

Jacob A. Zuber homesteaded in 1884 in what became Hintzville. Born September 16, 1851 and died April 13, 1933. He is buried in the Seabeck Cemetery with his wife. He was married to Sarah J. born March 11, 1858 and died May 14, 1933. They had a child named Edward. Mr. Zuber was mentioned in Hauptly's Diary Feb. 14, 1885. One of his neighbors was William Morgan. He signed a petition for a road from Gorst to Holly.

Mr. Zuber helped organize the Crosby Community Club in 1911. In 1891 he, with the help of Ashbel Hite, Thomas J. Lewis and George Stevens, built the first schoolhouse in Crosby.

Chapter Ten

After 1900 a couple events happened to add to the history of Seabeck area. The Conference grounds at Seabeck came about in 1914 and Camp Union came into existence in 1921.

In 1914 the J. Colman Co. purchased most of the Seabeck Tract. At that time they set aside 90 acres of that land for a Y. M. C. A. retreat. Before that they would meet at other locations up and down the Pacific Coast. When the Colman Company purchased the land they made Arn Allen the Manager. At that time Mr. Allen was General Secretary of the Seattle based Y. M. C. A. Mr. Allen ran the Seabeck Christian Conference for 28 years.

The following is an article written by Julia Allen (Arn Allen's wife) about how the Seabeck Conference Center came about.

"Previous to 1915 when the first Conference was held at Seabeck all Conferences had been held on the Oregon Coast, as in 1914 at a Hotel at Delano Beach. Trying to hold a conference, with other guests in the Hotel, was not easy and it was a dream of Mr. Stone and of Arn to have Conference grounds of their own for the Northwest.

Arn at first thought that if he could get ten men to give ten thousand dollars each they could buy some land and start one. As was often the case with his problems and because Mr. Colman was one of his board of directors and also a close friend he decided to talk it over with him. That proved to be a very wise idea for Mr. Colman was interested immediately and said, "Let's look around and see what we can find."

Now Mr. Colman loved the out of doors very, very much and it followed that he liked to own land, and when he and Arn could get away from time to time they looked at several places around the Sound, some of which they thought might do. Then they found Seabeck, a deserted mill town.

They were interested at once, Mr. Colman so much so that after due thought, he said, "I will buy the land and develop what is needed for the Conference Grounds." He not only liked everything about the beautiful location but also that there was adequate water on the property.

The mill had burned down and the town deserted for twenty-nine years. Some of the houses and buildings were taken down as they were not worth reconditioning but what was later called the Meeting House, Administration Building and ten of the houses were plastered and painted inside and out, and most of the roofs re-shingled. (The Administration Building is now the Inn, and cottage one was torn down several years ago.)

There was a boat which had been used for the Seattle and Tacoma run, which was abandoned at that time and Mr. Colman was able to get some furniture from it for Seabeck. When I was at Seabeck the summer of 1964, one of those reed chairs was on the veranda and I felt I would like to paint it and make a cushion for it as I had done for the two or three I had used in our cottage.

Mr. Colman's mother had a great deal to say about anything her sons did and as the grounds were made ready for the conferences she said they must have white sash curtains and white bed spreads on the beds, so both were provided and added a homelike appearance to the very simple furnishings provided in the beginning. (Some of these old white bed spreads are still in use as mattress pads for some of the double beds at Seabeck.)

When the grounds were ready, Mr. Colman said to Arn, "The grounds are ready but I don't know anything about running a conference." It was then that Arn said, "I will manage them for a year or two," never dreaming that he would be there for twenty-nine summers. (There were three successive twenty-nine year periods in Seabeck history: the mill from 1857 to 1886; the deserted town from 1886 to 1915; and the conferences under the management of Arn Allen from 1915 through 1943.)

Because salaries were so very low in those early days---Ministers we all knew with families, often receiving one hundred dollars a month---Mr. Colman said to Arn, "I would like the cost to the guests kept as low as possible so that Ministers can come here and get an inspiration that will last them throughout the year, also students with little money will be able to attend the conferences."

Arn's great desire was to show Mr. Colman in every way he could show something of his appreciation for this great thing that he had done, not only for his own beloved Y. M. C. A. but for the whole Northwest, so he tried hard to manage Seabeck as economically as possible, also so he would have a little money at the end of the season to return to Mr. Colman.

From the very first he had the wonderful help of Mr. Ben Berg, and very soon that of Mrs. Rachel Rose and Mrs. Fussell.

Arn inspired everyone with the desire to do everything they could to make Seabeck a Conference Grounds that Mr. Colman would be proud of.

In the beginning a cart with large wagon wheels was used to convey things from place to place, as for instance, the mattresses from the cottages fartherest away were brought to the lobby of the hotel for the winter for fear they might be stolen. Candles were used in the cottages

and gas lamps in the hotel. (Mr. Berg's son relates that many times he dumped the day's garbage from the cart directly into the Canal.)

Arn spent many hours in his little 'Office' keeping track of every bit of food used for each Conference, the number attending, and all the things pertaining to the staff and grounds, but still he found time to sit out on the edge of the ball field to watch a ball game with Mr. Berg. The friendship of those two was a joy to see.

In those days much of the work of the Seattle Y. M. C. A. was managing the Summer Camps the three months of the summer and Arn had capable people such as Charles Norman to do that and secretaries in Seattle that had been with him many years, many having come right from College to be on our staff. He was in once a week for a Staff Meeting and was as close always as the phone.

July 21, 1966

Chapter Eleven

As communities appeared, some of them had businesses. Camp Union at its peak had several businesses. At one time it had an ambulance service, two taverns, store and facilities for a railroad like a roundhouse, cookhouse, bunkhouses, and family houses furnished by the logging company. Through the years it's the only community to have survived with multiple businesses besides Seabeck. Tom Murray, who established a logging camp at Camp Union, used to have a logging operation on the west side of Hood's Canal, moved his operations to the west side of Seabeck Bay and then built a railroad track up to Camp Union to be the center of operations.

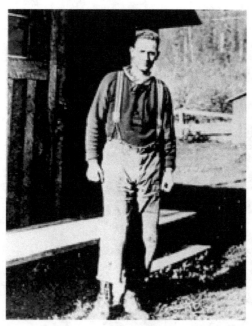

Tom Murray – Photo out of author's collection

A few years later, Tom Murray's operation (West Fork Logging) was sold to Charles R. Mc Cormick Logging Company of Delaware and Tom Murray moved his operations to Mineral Washington.

In 1938 the Charles R. Mc Cormick Logging Company of Delaware defaulted on a loan and the ownership went to Pope & Talbot, and they ceased operations at Camp Union. At Camp Union's peak of operations it employed about 350 workers. Many of the workers were transient and their names appeared only briefly on the payroll records that I was able to obtain. Several of the names were of families that stayed and took up residency locally or were already local such as the Hintz family, Emel family, Davis family (My grandfather on my mother's side), Broderson family, the Just family, and the Christopher family, just to mention a few.

In 1928 or 1929 a forest fire started and burned almost to Belfair. At that time the camp foreman was Cyrus Walker.

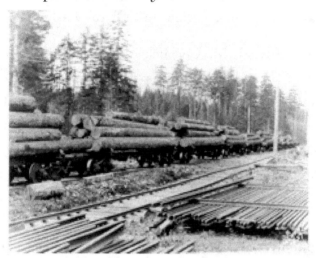

Logs ready to go to the log dump at Seabeck

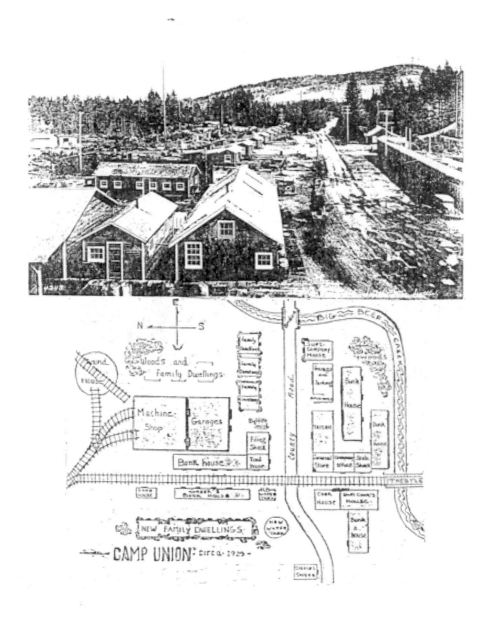

Camp Union lay out – Photo out of author's collection

My Uncle Fred was the first fatality at Camp Union. He was working on the landing where the logs were brought into for bucking (trim-

ming) when the bull block (a large pulley in the top of a spar tree) came loose and struck him on the head. This occurred in August of 1921.

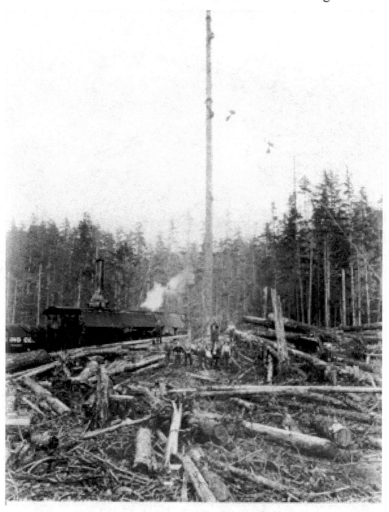

Spar tree near Camp Union, Photo out of author's collection

The logging camp at Camp Union set the world's record for getting out of the woods the most board feet of logs in a single shift. I was told that the crews got into place and waited for the whistle to blow. Several people told me that the next day you could walk across Seabeck Bay on the logs. As far as I know, that record still holds to this day.

There was four locomotives operating out of Camp Union: a little Shay, a big Shay, a Baldwin, and a Climax.

The big Shay used at Camp Union – Photo out of author's collection

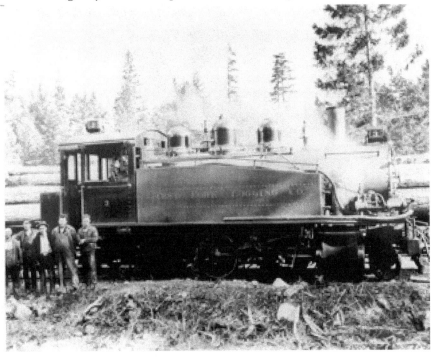

The little Shay used at Camp Union – Photo out of author's collection

Water tower for the railroad. Joyce Moan standing. Photo taken in the 1950's. Photo out of author's collection

Water tower for the community of Camp Union,
Photo courtesy of the Houde Collection

The following are some of the pictures of the logging operations that were being performed out of Camp Union:

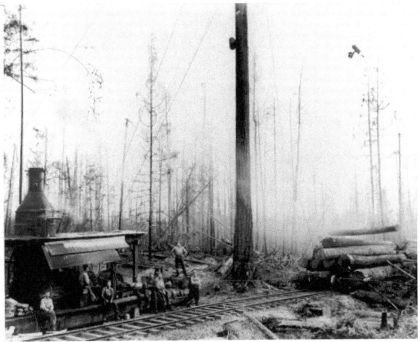

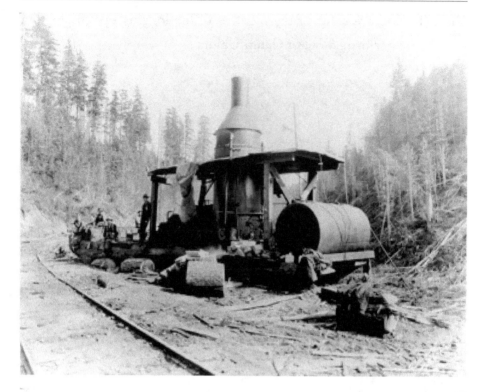

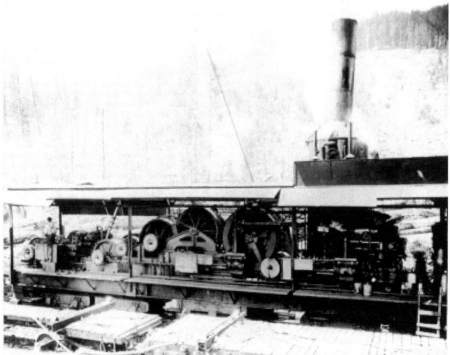

Ledger wood skidder – Photos are out of author's personal collection.

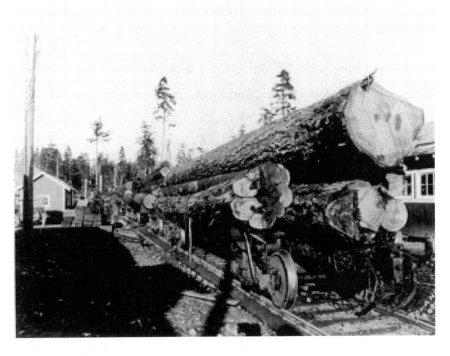

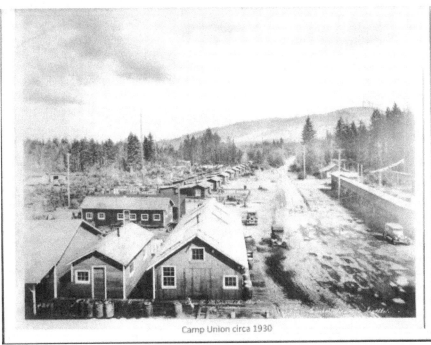

Camp Union circa 1930

— Photos are out of author's personal collection.

Water for the camp was furnished from a reservoir about half a mile south of the camp, and water for the trains was furnished from a well.

After the logging camp closed the only business left was the store which had gas pumps. During the camp days the Eyler family ran the store. After that Walter and Lenora Moan purchased the store. In 1950 the store caught fire and burned. There was snow on the roads and the fire department could not get there in time to save the business. The store was rebuilt by the Moans' and continued operation until 1979 when it was purchased by Mike Gross. In the 1940's Don Moan built a bus barn and residence and owned and operated the Crosby Bus Lines which ran between the Navy Yard and Crosby furnishing transportation for the workers.

Camp Union Service before the 1950 fire, Photo courtesy of Donna Moan

After the store burnt it was rebuilt by the Moans and continued operation.

The store after being rebuilt by Walter and Lenora Moan
Photo courtesy of Donna Moan

Dial phones didn't arrive in the Crosby/Camp Union area until 1961. The first dial phone Walter Moans', and the second was at the William B. Lewis resident.

By the 1980's Jim Thompson's Arrowhead Realty had opened an office at Camp Union and a feed store had started a business next door to Arrowhead in the same building which had been the former bus shed. In 1995 an arsonist set the building on fire totally destroying both businesses.

In 1988 Julius Templeton purchased the buildings and land. Mr. Templeton built a new store with space for Arrowhead Reality and an office for the Kitsap County Sheriff's Office to use as an extension office to

be used for doing paperwork without going all the way back to Port Orchard.

Upon completion of the new store, the old one was remodeled and opened and operated by Jeff Hughs as a pizza parlor. The building that was the Camp Union Saloon and Breadline became the Camp Union Cookhouse owned by Fred Just, and operated for nineteen years.

Also, after 1950 most of the camp structures disappeared from Camp Union. Most of the buildings were moved by Tommie Monroe down to Kitsap Lake.

The railroad trestle which spanned Big Beef finally rotted away and collapsed.

The trestle that spanned Big Beef at Camp Union when new. Photo out of the author's collection

The water tower became a danger and was pulled down by Lester Just.

Lester N. Just on his D-4 Catapillar, Photo out of author's collection

Chapter Twelve

Prohibition in the Seabeck and Crosby area brought about many stores about the citizens. I will relate some of them as I heard them. The exact truth may never be known as this is mostly oral history. Facts are scarce because it was an illegal activity. I will start with one that does have some facts that can be established.

There was a man that lived at Lone Rock by the name of Fred Miller. Mr. Miller moved here from Ohio. He was a remittance man. That being a person that is paid to stay away from his family. He purchased the Clark property that was located between the mouths of Big Beef and Little Beef.

Mr. Miller had the first seaplane in Seabeck which he used to run booze out of Canada.

Fred Miller's seaplane, Photo courtesy of Mr. Chadwick

He also had a launch built using lumber cut by John Walton's mill nearby. The launch was built by the Johnson Brothers of Seattle at Little Beef and named the "Discoverer" and was 60 feet long. He used the launch to run up to Whiskey Spit where he picked up booze that had been deposited by runners from Canada. After prohibition the launch was used as a mail and passenger boat up and down the Hood's Canal.

There was also a scandal involving Fred Miller. A baby was found in a suitcase over the bank by his house. It was speculated that he had killed his housekeeper and the baby was hers. Mr. Miller also had a common law wife named Georgia.

Just down the road towards Seabeck lived Sheriff Stanioch. Stanioch had a good thing going with the prisoners from the county jail. He used them to build his log house which is still standing. Another thing which I think was a good gesture was that he used the prisoners to cut wood for old folks and to do repairs around their homes.

On the other side of the coin, he would take payoffs. If you were involved in bootlegging, you had to give him a cut or go to jail.

The following is copied from the Bremerton Sun:

Of prohibition-Depression Years

That the prohibition era was one of the more colorful chapters in local history, the reminiscences of John Stanioch of Seabeck are convincing. Having served as chief of the police for the city of Charleston in 1920 and performed the duties of sheriff for Kitsap County for an unexpired term and two full terms from 1922 to 1931, he knew the prohibition problems at close range.

The firm assurance the old-time law-enforcer offered, however, is that prohibition days were "messy at best"---an era better forgotten than excavated for review.

As subsequent legislation indicated, the virtuous Volstead Act, though noble in aspiration, resulted mainly in dire headaches for law enforcement agencies and dire stomach aches for consumers of poorly distilled brews. As Stanioch sums it up: "The people who

drank continued to drink, so every person in possession of a bottle was a potential lawbreaker and had to be watched."

ILLICIT LIQUOR dealing in our well-watered locale were frequently carried on by boat. An innocent beachcomber strolling along on Blake Island came upon a sizable cache of liquor and in his alarm notified the county sheriff's office. Stanioch and his aides with the assistance of federal agents arrived on the scene and dug in to await further action. Their efforts were well rewarded when they nabbed skipper, boat, a crew of longshoremen and the cargo they came to load---some 20 barrels of beer and 40 cases of liquor.

Another time in a hasty retreat from a prospective landing at Harper, a rum-running boat dumped its load of spurious spirits and left a wake of ambitious residents busily retrieving bottles by means of pike poles and boat hooks.

Many stills were confiscated, but the smaller home operations in this field were so numerous that detection was difficult. One of the more aspiring moonshine factories was just achieving an elaborate setup at a Bangor ranch when Stanioch and federal authorities brought it to a premature halt.

THERE WERE some compensations for the worrisome prohibition law enforcement, however. One of the law's stipulations was that a portion of the funds (Note: one full line was missing from my copy of the article.) office to purchase better equipment for chasing lawbreakers. The single Ford the department owned was augmented by a second and later by more powerful automobiles for hunting moonshiners and rum runners.

High-powered cars of the day were no spectacular asset, however, since the few roads that existed didn't lead to some of the remote destinations a sheriff needed to reach. Stanioch recalled that if he left the courthouse to make a call in the morning, he seldom could hope to make his destination and the journey back in the same day. Many times he would go as far as the road, and had to hike the rest of the way.

On one jaunt to pick up an insane man at Eglon, it was necessary to hire a boat out of Port Orchard and make the water trip around.

THE SUBJECT OF ROADS brings earlier recollections from the one-time sheriff.

When he lived in Charleston whose city limits ended on High street, it was most difficult to commute to Bremerton. The only passable road was the one through the navy yard. "Of course," he said, "you

could make it over the trail up Krantz's Hill, but it took a lit-
tle doing." Krantz's Hill was the incline from what is now Naval
Ave. along Burwell St. The Krantz family operated a general store
where the Red Rooster, Rivas upholstery shop, and barbershop are
located now. Their home was the large square house of the corner
of Naval and Burwell.

Bremerton and Charleston were complete unto themselves in those
days---who needed an automobile? There were no roads leading into
or out of the two towns when Stanioch chose the area as his home
after his discharge in Puget Sound Naval Shipyard from service
with the Marine Corps back in 1909. Commerce and travel were car-
ried on by water. He remembers having made the Brinnon to Seabeck
ferry trip somewhere in the '20's.

FOR THE LAST 24 years, Stanioch and his wife have made their home
in a spacious log house with its rolling lawns and picturesque
gardens fronting on Hood's Canal just north of Seabeck. The road
that up until 10 years ago was a wandering route of the old "Ter-
ritorial Trail" along which mail was delivered from Shelton to the
old mill community at Seabeck and came to an end at Port Gamble,
the other thriving mill town of that era.

The years Stanioch served as sheriff was distinguished not only as
"dry" years, but as depression days.

Economy was the fashion by necessity and extended into the manage-
ment of the county jail. By arrangement with the federal govern-
ment, prisoners who had been sentenced by U. W. courts in this area
could be retained in the county jail with the federal government
paying 60 cents per man per day for subsistence. On this magnan-
imous income, Stanioch managed to feed county prisoners too. He
had in his charge as many as 60 federal prisoners at a time. Food
supplies were augmented by the jail's own vegetable garden and the
sacks full of salmon, so plentiful that fishermen couldn't give them
away otherwise.

IT IS A MATTER OF pride to Stanioch that his operation of the
sheriff's department stayed well within a budget of $12,000 a year.
He believed that labor was a healthy thing for all prisoners, so
other than those awaiting immediate trial on some serious charge,
every incarcerated man was put to work.

During Stanioch's regime, the courthouse heating system was con-
verted from coal to wood, and prisoners seemed contented with
their lot of sawing and splitting wood. At time when there was a
surplus of wood, prisoners would be so pleased with their virtuous

efforts that they would not only split wood for needy aged welfare
recipients, but would carry it into the house. Stanioch expressed
his gratification at having helped these early time prisoners to
ways of better living as well as being able to assist the needy.

"They weren't animals, really." He says, "Just bootleggers and
moonshiners trying to figure a way to make a little money when it
was awfully hard to come by."

OTHER WORDS of approbation come from the law enforcer about ju-
venile delinquency in his day. The young people of Kitsap County
were hailed by Stanioch as being the finest (Note: full line of the
article missing from my copy.) planned recreation activities---but
also not much opportunity for mischief. Nearest thing to a prob-
lem the sheriff faced was the hot rod of the day---"bug" to the
jazzier set---but speeding was not a practical thing, since the
number and condition of county roads imposed great limitations.
He recalled that a number of youngsters felt challenged to sample
bootleg whiskey---"youngsters" among whom are some present day lo-
cal fathers with sons carrying on other experiments---but he felt
the violence of the stomach upset that ensued was far more effective
punishment than his office could mete.

The sheriff's office in the '20's staffed by the sheriff, a jailer,
part-time matron, chief and two other deputies, had no ambulance
anywhere in the vicinity at its disposal---the sheriff or his dep-
uties traveled to the scene of an accident and as best they could
bundled the injured to the nearest doctor.

IT WAS NECESSARY to build a new jail to house the prisoners. It
was then located on the hill between Retsil and Port Orchard and
was in full operation. All in all, they were busy, constructive
days in spite of depression and prohibition.

In retirement the last few years---at least from law enforcing,
logging and labor union duties---Stanioch and his wife manage to
lead a busy life keeping up the spreading gardens and beach that
surround their home. The parade was an exciting and busy one while
he was marching in it, but the prohibition-day law enforcer finds
that time and distance have mellowed some of its aspects and he
finds the role of spectator to today's passing parade a pleasant
one.

(End of the article)

According to some old-timers, a still was set up at Dewatto and the booze was run as far as Wildcat Lake where it was picked up and transported to Kitsap Lake where it was distributed to points around Bremerton.

While going through the funeral home records I saw where there were several deaths due to liquor poisoning during the time of prohibition.

There was one particular bootlegger that operated well into the 1960's was a man called Pappy Burton. He was arrested three times and even told that if obtained a license he could make up to a certain amount each year. But Pappy enjoyed trying to get away with what he was doing. For a while he drove the Silverdale taxi using a station wagon. He got pulled over for a traffic infraction and the police found the back of the taxi full of corn mash for making moonshine. Another time he was living in Bremerton on Elizabeth Street and set up a still in his basement. He funneled the steam from the still into his chimney so it would look like he had a fire going. The Feds had been watching him and happened to notice that the smoke coming out of the chimney was dissipating awfully fast, so they raided his house and found the still.

My father was still buying white lightning in the 1960's. He wouldn't tell me where he was getting it. I found out later that he was buying from the man that operated the county road grader. The liquor was kept in a gallon jug labeled distilled water.

Chapter Thirteen

Footnotes to Seabeck and the surrounding communities

The following persons deserve to be mentioned as they helped build Seabeck and the surrounding communities or had ties to the area for one reason or another.

William J. Adams: Mr. Adams was the grandfather of the famous photographer Ansel Adams. He and Marshall Blinn founded the community of Seabeck.

Hiram Doncaster: He built several ships at Seabeck including the "Olympus" which was the largest single-decked sailing ship ever built on the West Coast.

Lawrence and Kenneth Colman: They founded the Seabeck Christian Conference Center which has been a mainstay in Seabeck since 1914.

Ester Clayson Pol: She became the first woman to be listed in the Medical Who's Who. Ester achieved many awards because of her contributions to the medical field.

Floyd Lowe (Curly): He was a partner with a man named Barrett owning the Barrett & Lowe Air Taxi which operated between Bremerton and Seattle.

Norris (Big Jim) Whitaker: He grew up in the Seabeck and Lone Rock area and became a construction superintendent and project manager. He was responsible for building some of the largest and most complex projects in the world, including major portions of the Trans-Alaska

Pipeline, eight of the largest dams in the United States, major portions of the interstate highway system, large mining projects, and a major port in Saudi Arabia. He died on September 29, 2006.

Jack Dempsey: He worked briefly in 1934 at Camp Union for the Charles R. Mc Cormick Lumber Company of Delaware as a faller and bucker.

Robert Lewis: He was the son of Thomas J. Lewis that homesteaded in Crosby. Robert became part of the upper echelon of Weyerhaeuser Timber Company.

Appendix I

List of names of persons buried in Seabeck Cemetery

Allen, James	1868		
Ames, Ellen	Aug. 8, 1898	Jun. 20, 195455	
Ames, Raleigh	1970		
Andersen, Emel	Jun. 7, 1893	Jun. 12, 1893	5 days
Andersen, Emma	Nov. 9, 1894	Nov. 30, 1894	21 days
Andersen, Hulda	Jan. 15, 1873	Aug. 20, 1900	27
Andersen, Oluf	1860	1909	49
Baker, J. G.	Mar. 5, 1885		
Baker, Millie	1875	1876	1
Baker, Nichols S.			
Barrett, Jason	Mar. 26, 1883		
Basset, Ann			
Basset, Samuel J.	1850	Jun. 23, 1940	90
Beatty, James			
Bell, William	Oct. 17, 1831	Jan. 17, 1869	38
Benson (child)	May 27, 1885		
Bolan, Ida Hintz	Apr. 21, 1860	Jun. 1, 1937	77
Bonny, James	May 30, 1877		
Bowker, Frances	Oct. 15, 1881		
Bowker, Sam	Jun. 8, 1883		
Bradley, Marjorie	Jan. 22, 1880		
Branham, Helena C.	Jun. 16, 188	Apr. 29, 1932	43
Brown, Amos			
Brown, Larry	Dec. 22, 1932	Jan. 23, 1933	1 mo.
Brown, Sarah	Aug. 26, 1864	Feb. 13, 1928	63
Brown, William B.	Aug. 20, 1908	Oct. 18, 1943	35
Bryant, Hiram	1823	Jan. 28, 1868	45

Burn, Leo	Oct. 29, 1889	Oct. 29, 1889	
Butcher, Thomas	Apr. 21, 1883		
Butcher, Thomas H.	Feb./Mar. 1879		
Card, William Pierce	Mar. 3, 1858	Apr. 1, 1926	68
Cichey, Andrew	Nov. 17, 1865	Feb. 27, 1936	70
Clements, Ann	1838	Jul. 19, 1880	41
Clements, John			
Clough, Caroline			
Clough, Julia Anne	Sep. 29, 1856	Nov. 7, 1938	82
Clough, Warren Lewis	1847	Oct. 7, 1923	76
Cottle, Ursula	1830	1872	42
Craft, Mary	1859	1915	56
Craft, Thomas H.	1855	1918	63
Dahl, Anna	1894	Jan. 25, 1919	25
Dahl, Borghill			
Davis, Bert Victor	Jun. 9, 1925	Jan. 14, 2008	84
Emel, Peter F.	Dec. 25, 1853	Feb. 21, 1924	80
Emel, Ruby C.	1909 Apr. 17, 1911		3
Fenwick, William	Nov. 23, 1854	Mar. 16, 1947	92
Fogg, Horace	1848	Jul. 23, 1878	40
Foley, John	Jul. 23, 1878		
Furgur, Joe	Jul. 30, 1878	Dec. 20, 1938	60
Hafner, Karoline	Feb. 20, 1865	Aug. 16, 1936	71
Hagan, Jacob	1905 or 1905	1906 or 1907	2
Hallier, Sofie	1885	Sep. 16, 1888	3
Hanby, Leslie C.	Jun. 27, 1926	Dec. 20, 1933	7
Hintz, Julius	Mar. 14, 1857	Jan. 10, 1928	70
Hite, Alice J.	Jan. 28, 1853	Feb. 28, 1931	78
Hite, Ashbel F.	Jun. 15, 1847	Aug. 16, 1931	84
Hite, Robert Bruce	Sep. 1, 1881	Dec. 11, 1951	70
Hoar, Evelyn	Jul. 12, 1905	Jan. 2, 1971	65
Hoar, Johnny	Nov. 23, 1891	Feb. 8, 1970	78
Howe,			
Hunt, William	1923		
Johansen, Carl Albert	Sep. 2, 1891	Jul. 29, 1896	4

Johnson, Albin T.	Jun. 11, 1882	May 2, 1901	18
Johnson, August	1848	1926	78
Johnson, Edward	Oct. 30, 1882	Nov. 4, 1930	48
Johnson, John A.	Jun. 26, 1846	Dec. 26, 1926	80
Johnson, John August	Sep. 4, 1848	Jan. 2, 1926	77
Johnson, Louisa	Sep. 20, 1848	Apr. 21, 1904	55
Johnson, Maggie	Apr. 12, 1847	Oct. 5, 1925	78
Johnson, William	Oct. 5, 1858	Nov. 27, 1938	80
Johnston, (infant)	Apr. 2, 1931	Apr. 9, 1931	7 days
Johnston, Norma L.	Apr. 18, 1931	Dec. 6, 1932	1
Johnston, Wayne	Jun. 29, 1935	Sep. 24, 1935	3 mo.
Johnston, William F.	Aug. 12, 1867	Apr. 25, 1939	72
Just, Andrew	Oct. 8, 1859	Jul. 25, 1928	67
Just, Andrew Glenn	Jan. 6, 1966	Mar. 3, 1993	27
Just, Frederick Ralf	Sep. 27, 1903	Jul. 30, 1921	17
Just, Lester Ernest	May, 25, 1940	Jun. 4, 1999	71
Just, Melvin Earl	Apr. 27, 1928	Jul. 31, 1999	71
Just, Richard Carlton	Jul. 1, 1909	Feb. 2, 1932	22
Just, Venice Irene	1937	2005	68
Juvan, John	1875	Nov. 23, 1928	53
Keegan,			
Keegan, William	May 15, 1838	Aug. 25, 1880	42
King, George B.	Nov. 18 25	Dec. 17, 1875	49
Langworthy, Harvey J.	1895	Apr. 28, 1923	28
Lantz, (Mrs.)	Apr. 4, 1880		
Lantz, Richard	Apr. 1872	Aug. 20, 1878	6
Lewis, Elizabeth	Jan. 16, 1833	Feb. 10, 1913	80
Lewis, Henry King	Feb. 5, 1882	Feb. 6, 1882	1 day
Linde, Anna	1885	1909	64
Little, Clara E.	Apr. 5, 1868	May 9, 1885	17
Maher, Elizabeth Emel	Jun. 16, 1875	Apr. 29, 1909	33
Matson, John M.	1894	Oct. 26, 1903	9
Mc Donald, Angus	Jun. 17, 1873		
Mc Donough, William C.	1856	Oct. 30, 1888	32
Miller,			

Miller			
Moran, Sarah	Jul. 18, 1882		
Moran, William	Nov. 15, 1836	Nov.27, 1909	73
Myhre, Brithe	1830	1894	64
Myhre, Niles	1829	1893	64
Nelson, (Mr.)	Apr. 17, 1879		
Nelson, Anna	Jul. 7, 1850	Jan. 21, 1934	83
Nelson, Malina	Jul. 3, 1853	Apr. 12, 1894	40
Neyhart, Ralf Jacob	Jun. 3, 1888	May 19, 1969	80
Neyhart, Robbin			
Nickels, August (Gussie)	1880	Mar. 4, 1954	74
Nickels, Clara (baby)	Jul. 16, 1874		
Nickels, Clara	Apr. 13, 1845	Apr. 30, 1923	78
Nickels, Frank	1877	Nov. 15, 1901	24
Nickels, Samuel	Jul. 22, 1840	Mar. 16, 1924	83
Noble, Joseph	Apr. 4, 1874		
Olaine, Agnes	1887	1889	
Olsen, Bessie			
Pierce, (child of Thomas Pierce)	1862		
Pierce, (twins)	Mar. 20, 1882		
Prosch, Frederick	Aug. 7, 1848	Aug. 24, 1901	53
Rensch, Frank B.	1859	Dec.12, 1914	55
Rensch, Paul	1847	1911	64
Rogers, Albert	Jan. 25, 1867	Aug. 4, 1930	63
Rogers, Frances	Jan. 2, 1892	May 16, 1943	51
Rostad, Christian	Oct. 7, 1862	Dec. 12, 1945	83
Rostad, Edward	Feb. 14, 1917	Jul. 13, 1933	16
Rostad, Marie F.	Mar. 24, 1876	Dec. 10, 1945	69
Russell, Martha	Sep. 11, 1864	May 31, 1940	75
Russell, William J.	Nov. 27, 1862	Sep. 17, 1938	75
Sargent, Nathanial J.	Jul. 7, 1863	Aug. 16, 1954	91
Sager, Jacob	Aug. 25, 1877		
Scott, Gustaf		Sep. 12, 1926	
Scott, Sophia (Fredel)		Mar. 16, 1918	
Selby, Joe S.	Apr. 3, 1889	Apr. 26, 1958	69

Selby, Margaret Wilson	Sep. 1, 1862	Aug. 3, 1935	73
Selby, Mary I.	Jan. 16, 1893	1907	14
Shaffer, Henry (Harry)	1840	Jul. 8, 1880	40
Sheridan, William	Jun. 1881		
Spencer, Hannibal H.	Nov. 5, 1862	Jun. 1, 1945	82
Stilwell, Sarah	Jun. 16, 1858		
Stout, Margaret S.	Oct. 31, 1885	Jun. 28, 1932	47
Swank	Feb. 2, 1881		
Taylor, Glen W.	Jun. 27, 1888	Jan. 11, 1960	72
Uelan, Oscar	1953		
Veldee, Martha	1893	1893	
Veldee, Pearl Irene	1901	Jan. 17, 1903	2
Voegele, Barbra	Dec. 4, 1847	Jan. 23, 1916	68
Voegele, Edward	Nov. 20, 1849	Feb. 15, 1930	80
Wallace, Marie			
Wanderschied, Anna	Apr. 16, 1868	Mar. 5, 1938	69
Wanderschied, frank	Dec. 6, 1861	Apr. 9, 1936	74
Wares, George	1876		
White, George	1844	1874	30
White, Jason H.	Oct. 19, 1883		
Whitney, Calmon	1836	Jul. 13, 1880	54
Williams, Grizzley	1865	1911	46
Williams, Walter J.		1860	
Wilson, Dempsey	Feb. 2, 1823		
Wilson, Margaret	Jun. 4, 1829	Jul. 14, 1912	83
Wilson, Minnie	Nov. 21, 1890	Apr. 27, 1962	71
Wilson, Nellie A.	Mar. 19, 1859	Nov. 3, 1916	57
Wilson, Sydney J.	Feb. 7, 1866	Apr. 16, 1934	68
Wood, Charles	1845	May 7, 1916	71
Wood, Elizabeth	Apr. 10, 1863	Dec. 3, 1924	60
Woodhouse, John (Worked for Berg's)			
Woodhouse, Joshua	1842	Dec. 15, 1873	31
Zuber, Jacob A.	Sep. 16, 1851	Apr. 13, 1933	81
Zuber, Sarah J.	Mar. 11, 1858	May 14, 1933	75

Names added by Fredi Perry in her book

Seabeck: Tide's Out. Tables Set.

Frances, Frank			
Little, Helen (Walker)	Oct. 1827	Oct. 26, 1901	74
Melenowski, Frank	Oct. 23, 1906	Jan. 8, 1907	
Nelson, Andrew	Feb. 12, 1849	Mar. 19, 1917	68
Nelson, Johan Frederick	Apr. 12, 1934		
Thompson, Merle	1856	1953	

Possible names of persons buried in Seabeck Cemetery

These names are listed in Register of Deaths
kept at the Kitsap Co. courthouse

Evans, John	Nov. 17, 1893	73
Hobbs, Cecilia Mary	Nov. 25, 1899	25
Hotchkin, A. L.	Oct. 16, 1899	66
Hotchkin, Harry H.	Jun. 20, 1895	14
White, Joe	Oct. 30, 1883	

These names have been told to me by other people,
but I was unable to substantiate.

Baer, Jacob	Apr. 21, 1855	Apr. 22, 1929	74
Crowell, Al	About 40 years old		
Curtis, Roy Dell	Dec. 25, 1868	Nov. 28, 1935	67
Emel, Edith H.	May 20, 1889	Nov. 25, 1931	42
Emel, William V.	May 8, 1888	Jul. 27, 1938	55

Appendix II

TOURIST'S GUIDE

The Northwest Coast has not yet become a tourist's Mecca, owing, undoubtedly, to the fact that the beauty, wild grandeur and diversified scenery of water, forest and snow-clad ranges---rivals of the Alps---which are to be found along its entire length, have not been made known, or perhaps it has been thought too distant. The latter, however, seems improbable, when we know that persons have traveled from all portions of Europe for the special purpose of beholding the grand scenery of the Yosemite Valley or the awe-inspiring Geysers. A want of knowledge, then, of our unequaled scenery, must have been the primary cause for the scarcity of the seekers after the picturesque and beautiful. Though Washington may not possess a Yosemite or the Big Trees, it never-the-less has wonders of scenery which should attract any lover of the beautiful and sublime. It is scenery that is unique, and as diversified as it is peculiar. From the moment one enters Western Washington he is surrounded by towering forests of such magnitude that the evergreens of the East sink into insignificance by comparison. Many of the trees are between three and four hundred feet high, and from eight to sixteen feet in diameter. They very forcibly impress one of his diminutive forms, as he gazes at their tall, straight trunks, free from branch or leaf for a distance of forty feet from the ground. These gloomy forests, which have such a weird effect, are relieved by

the bright leaves of the laurel, maple, dogwood and the shrubbery and flora which grow profusely, and give them an appearance of tropical luxuriance. This flora contains many species new to botanists; hence it is very interesting to the lovers of botany. When one emerges from the forests the first objects that greet the eye are the snow-clad peaks of the Cascade and Olympic ranges, which loom in every direction. The effect of these is sublime in the highest degree. If the day is fine and the sun shining brightly, every prominent crevice in the peaks are discernible, and the play of the light upon the snow and its many and quick changing hues become interesting to the lover of the harmony and wealth of color. This is especially the case in the morning or evening. On such occasions all the hues of the rainbow can be seen at once, sometimes fading into one color and then again transforming until all known hues are developed. Much as has been written of the beauties of the Alps, we doubt if they can excel those of the white-shrouded peaks of the Cascades. The adventurous tourist will find these worthy of all his daring and courage, and if he ascends them and happens to bear ay love for the natural sciences, he will find a wealth of flora and fauna which will surprise and charm him. All these mountains show the effect of glacial action, hence possess many peculiar characteristics. The ascent of Mount Vesuvius is deemed something worth boasting of: what then must it be to ascent Mount Rainier, St. Helens, Baker or Hood---peaks far higher and more strongly marked physically. If the volcanic displays of Vesuvius is the attraction that lures tourists, they will find Mounts Rainier and St. Helens also interesting they being active volcanoes, though at rest since 1842; never-the-less the craters are objects of interest. Tourists will find these mountains wealthy in new species of animals and flowers. Of the former the most interesting are the mountain sheep and goat about which extra ordinary stories are told by hunters and Indians as to their swiftness, nimbleness and elasticity. Only a few of these have been killed.

An object of interest to tourists is the large number of mounds, varying in size from what might be called a small earth blister to one several feet high, and containing over an acre, which dot the prairies very thickly in many places. The origin of these is assigned by some geologists to the action of fishes, by another to the uprooting of trees, but the most probable theory is that they were caused by the action of whirl-pools, when the Puget Sound basin formed a portion of the great bed of the sea extending from British Columbia to San Francisco. This seems to be verified by the gravelly nature of the soil, which would indicate that it was once covered with water. Near the Cathlapootle River in Central Washington, there are a few mounds, but they seem to have been caused by the passage over wet ground of a mass of lava from Mount St. Helens, and elevated by the gas produced by the action of the heat upon the water. In Eastern Washington are still other varieties of mounds, and these, with the terraces which raise one above another, give the country very marked topographical characteristics. Whatever may be their origin, they give the landscape a strong peculiarity or individuality, and are interesting to the geologist. The terraces found principally in Eastern Washington, rise tier upon tier, one above another, to the number of eighteen or twenty in several instances. These seem to have been formed in the volcanic period, and to have undergone no change in conformation by the action of glaciers, though the country must have been under their control for many centuries.

The tourist will find the Territory unequaled for hunting and fishing, every nook and cranny of the mountains and forests being the home of game, either quadruped or feathered, while the streams are stocked with glittering mountain trout of the most excellent flavor. Besides the trout, varieties of salmon can be caught during any month of the after April. Salmon fishing is excellent amusement and calls out all the dexterity of the disciple of Izaak Walton, as this fish is very spirited and makes a gallant struggle for existence. He who desires to indulge in salt water fishing can find that sort abundant and varied enough from

the head of Puget Sound to the Straits of Fuca. Trolling is a favorite way with many of fishing on the Sound. Trout of brilliant hues are also common in all the lakes, and afford good amusement. Go where you will in the Territory you will find excellent fishing, and he must be a poor fisherman indeed who cannot bring home a load in the evening.

The hunting is unlimited. The sportsman will find in the forests several species of deer, the black bear, cougar or American lion, several species of the wild-cat, and along many of the water-courses the beaver, land otter and kindred animals. The feathery tribe is abundant in every portion of the country. There are five species of the blue grouse, two varieties of pheasant, three of wild geese, ten of duck, besides innumerable quantities for a day's gunning, and in every case he will meet with success, owing to the abundance of the birds and the facility of approaching them, as they are comparatively but little hunted. Thousands of wild ducks can be found in the autumn along the marsh banks of the rivers, while the goose frequents the sedgy borders of lakes and wheat fields after the crops have been garnered. The albatross, loon, gannet and other aquatic fowl are common along the Sound, and the swan in large numbers frequents the Lower Columbia, so that there is variety enough for all classes of hunters. Bear hunting is perhaps the most exciting, for bruin when wounded or closely pursued by dogs will show fight. The bear most common is the small black species, and he is no match for a man armed with a good rifle and hunting knife, hence the sport, though exciting, may be called harmless to the hunter at least. Bear may be found in almost any portion of the forests during the season of berries, as they subsist upon them and a few roots. Hunting the cougar is also excellent sport, and with dogs devoid of danger, as it will take to a tree when pursued and there falls a victim to the ready rifle. This animal never attacks man unless wounded or defending its young. The most interesting hunting is pursuing the deer, which are very numerous and of different species. These species or varieties have their particular places of resort and rarely leave them. Some frequent the

groves which border the prairies, while others keep to the heavy forests
which the sunlight but dimly penetrates, and there among the luxuriant
vegetation and in the cool shade browse in hundreds. In the winter
deer are very plentiful along the coast, as they are driven from the
mountains by the snow, but at any season of the year they are plentiful
enough to afford all the sport desired. They are generally hunted with
dogs and a man having a small pack can always depend on securing a
good number in a day. The elk, another species of the corvidae, is an
inhabitant of the mountain ranges. This is one of the largest varieties
of the family and also one of the beautiful. It affords excellent sport for
the keen huntsman who enjoys a little toil and wishes to test his powers
of endurance, as he will often be forced to follow it several miles unless
he avails himself of a "first view."

Besides these sports the Territory is also interesting to tourists and
pleasure seekers from its splendid prairies covered with groves, laid out
by the greatest of landscape gardeners---Nature. These groves rival
in beauty the finest of natural parks, and the latter sink into insignif-
icance in comparison of extent. When first seen as in Pierce County,
the effect is enchanting. Before you stretches the level gravelly prairie,
decked with innumerable wild flowers, while its borders are fringed
with evergreens and deciduous trees which harmonize most agreeable.
In one part a semi-circular cluster of trees can be seen in another it is
either a single, double or triple straight line extending for a mile or two
that meets the eye, in another portion the copse is of a crescent or cone-
like form, but in all cases the grove harmonizes with those surrounding
it. To add to the beauty, a cluster of crystalline lakes, upon which the
sunbeams dance and glisten, meets the vision in several places. A ride
or a drive through these natural parks, is a feast of scenery to be found
nowhere else in the world. In the first place there is the enjoyment of
having a beautiful turf road, which cannot be excelled, beneath you;
before you spread miles of flower beds, which perfume the air, their
brilliant hues being contrasted and made more striking by the quiet

shades of the evergreen groves or dark green of the oaks, while the towering snow-clad peaks, with their cool, refreshing appearance, make up a grand background and complete a tableaux which would be difficult to surpass.

For bathing, its facilities are superior to Cape May, Newport or Long Branch, Shoalwater Bay or Gray's Harbor outrank any Eastern summer resort in picturesqueness of location, while their splendid beaches are unapproachable. Add to these a milder climate and ample opportunities for hunting or fishing, and the difference between them will not even bear a comparison.

The Niagara of the Pacific Coast—the Snoqualmie Falls---is situated in the Territory, and but a day's travel from the sea-coast up the Snoqualmie River. This cataract is a fine body of water, ranging from twenty to eighty feet in width, according to the stage of the river, and leaps down a precipice of two hundred and seventy feet, where it mingles again with a stream until its waters reach the Sound. Though not, of course, equal to the celebrated falls of the county, yet their altitude, picturesqueness and beauty of surroundings render them an object of interest. No hotel or hostelry has yet been erected near it to accommodate tourists, but undoubtedly one will be built as soon as the travel demands it. The visitor with plenty of leisure time will find a canoe trip up the river leading to it a real pleasure tour, for by that means he will have an opportunity of leading to it a real pleasure tour, for by that means he will have an opportunity of beholding the scenery, and if fond of hunting can indulge in it to his heart's content.

By visiting the Territory the tourist will meet a race fast dying away before the advance of civilization. Their manner, customs, mode of thought and religion would interest any lover of ethnology, and would repay a study. The person who has "done Europe" and thinks his travels and experience complete, will find this people interesting. And he cannot anywhere discover a place he can so readily distinguish be-

tween barbarism and civilization, for here both are neighbor. A sight certainly worth seeing is a fleet of Indian canoes scudding down the Sound in route for the fishing grounds. These canoes are of all sizes, from the tiny shell to that sixty feet in length, and decked out gaily in all the varieties of red and yellow paint, which reminds one of the war canoes of the ancient North men. The beauties of the country should attract all who delight in grandeur and variety of scenery. Nowhere in the world can be found a grander tableau of water, forest, and snowy mountains than is to be witnessed from the bosom of Puget Sound. Before you spreads an inland sea, tranquil as a lake, over which move white-winged vessels, Indian canoes, ocean steamers and river boats, which give it life and character; in the middle ground lie the gloomy perennial forests, extending away into the distance until they become a mere mass of black or dark blue, and in the back-ground are the rugged, many-peaked mountain ranges, whose summits, wrapped in their eternal shroud of snow contrast with the gloom beneath them and give the whole landscape a light, purity and charm that is enchanting. All the accessories of a great picture can be found in almost any portion of Western Washington. We have seen from one spot a landscape which expressed repose and action, tranquility and energy, picturesqueness and grandeur, and the whole blended harmoniously together.

When the North Pacific Railroad is built, tourists, naturalists and mere pleasure seekers will undoubtedly visit the Territory, as the traveling accommodations then will be all that is needed. In describing some of the advantages of the Territory as a resort for tourists, we have merely referred to them in general, for to enter into detail would require more space than we have at hand in this work, which is intended only to deal with general facts. He who seeks pleasure and recreation, and not the hot-house commodity furnished in the fashionable watering places, will find what we have said of the Territory sufficient to lure him here, and if he comes once he will be sure to call again.

The best time of year to visit the country is about June or July, as it is then in its full attire of summer flowers, the skies are blue, the days balmy, without being hot, and the feathery game is grown to a size worth bagging. The best route to the country is by steamer from San Francisco to Portland---giving tourists an opportunity of enjoying the beauties of the Columbia and Willamette rivers---thence to Kalama by steamer, and from there overland by cars and stage. The trip should embrace the whole of Puget Sound, and when that is done Eastern Washington can be visited with pleasure.

RATES OF WAGES.

Many persons, doubtless, would be pleased to learn what class of me-chanics, laborers and domestic servants are needed in the country, and the wages paid. To the first query we would say that any person able and willing to work, unless he be a follower of the muses, can find employment. The persons most needed are farmers who are willing to hew themselves a home with their brawny arm, or have the means of improving land. Manufacturers are wanted to utilize in the country the productions of the country, and thus enrich that which should be enriched, and not allow all the profits ad control of the commerce to fall into the hands of those who have no interest in the advancement of the Territory. Mechanics are wanted; blacksmiths and carpenters can find plenty of labor to perform, and at salaries of from three to five dollars per day in gold. These can procure employment on the railroads in the course of construction for the next few years. Boiler makers and ma-chinists receive from five to seven dollars per day, but the demand for them at present are limited. Plasterers are in fair demand and receive from three to five dollars per day. Their labor will soon be wanted, however, rather extensively, for when once the railroad terminus is set-tled buildings will shoot up like magic all over the western division. Good waiters are always in active demand, at a salary ranging from

thirty five to forty dollars per month and board. Wagon makers and coach builders receive from three to five dollars per day; the latter are not much needed just now. Day laborers receive from forty to sixty dollars per month, and are always active, as large numbers are required around the mills, logging camps and to work on wagon roads and railroads. Good axe men, as loggers, get from sixty tone hundred dollars per month, and employment is always sure, owing to the activity of the lumber mills, which run the year round. Teamsters receive about the same salary, and mill hands from thirty-five to fifty dollars per month, with board. Cooks receive from fifty to one hundred dollars per month and board, according to capacity, and clerks from sixty to one hundred dollars. Book keepers average one hundred dollars per month. But few of the two latter classes are wanted, though those well up in their business may be sure of securing a position readily. Sailors receive thirty-five dollars a month on coasting vessels and twenty of foreign. School and music teachers are in good demand, though the wages paid to the former are rather small. That business is principally monopolized by the gently sex, hence pedagogues would not find the country a good one for speculation in their profession. A school can be found in the interior, but the salary would not exceed thirty or forty dollars a month and board, the latter being furnished in the western style of boarding around among the pupils. Music teachers fare better, and are usually well paid. Female servants, for the house, are perhaps the best paid, proportionately, of any class of employees, as they receive from twenty-five to forty dollars per month, and quite scarce at that, so the Chinese have assumed their position. Good chamber-maids or cooks can find ready employment and be treated with courtesy and democracy, not aristocracy, is the rule here. One hundred girls could find positions within one week after their arrival in the Territory. Farm hands are also in active demand and receive from thirty to forty dollars per month and board. Literary men, men of Micawber's character, loiterers of followers of the fickle goddess, are not wanted and had better keep

away. If the good graces of Fortune are to be gained here, the goddess must be wooed persistently. The motto that "fortune favors the brave" will be found a good one here, for it is only the brave of heart, the ready, willing toiler that is desired. He is needed to advance the country, to help place it among the first ranks of the States of the Union. It possesses the wealth and resources, all required is their development. Kid-gloved men, persons of extremely fine sensibilities, flaneurs are not the characters to develop these, but rather the laborious and courageous man who fears not toil, and is willing to work hard at present that he may enjoy his ease hereafter.

Bibliography

Lewis Funeral Home

Woodlawn Funeral Home

Washington Mill Company Records

The Enterprising Mr. Murray

Prosch's Scrapbook

Kitsap County Records

Central Kitsap School Records

Various Abstracts of property

Events in the History of Crosby by Ernest Riddell

Kitsap County Plat Books

Family Histories

Seabeck Cemetery

Hauptly's Diary

Ten Years among the Indians by Myron Eells

Seabeck History by Priestly

Images of History: Jefferson County

Images of History: Hood's Canal

Historical Narratives of Puget Sound by Edward Clayson

Charles R. McCormick Lumber Co. of Delaware payroll records of Camp Union

Crosby Community Club Scrapbook

Various Newspaper articles

Elsie Christopher's personal notes

Kitsap County History Book

Kitsap County Historical Society Collections

Tacoma Historical Museum

Maritime Historical History (3 volumes)

Seabeck - A near metropolis

Central Kitsap: Seabeck and vicinity

Individuals:

Jerry Houde

Elsie Christopher

Verne Christopher

Bergie Berg

Joe Emel Sr.

Rudolph Hintz

Lester N. Just

Alice Houde

Raymond Fowler

Marie Halverson

Ella Olaine

Tom Murray Jr.

Bob Christensen

Joe Rostad

Nancy M. Just

Warren Lewis

Robert Lewis

Mike Mjelde

Jessie West

Ames family

American Cyclopedia, The (1881)

Encyclopedia Britannica (1911)

The Rebel Battery

The Seattle Post-Intelligencer

The Tacoma News Tribune

Washington: A History of the Evergreen State (1961)

Shipwrecks of the Pacific Coast by James A. Gibbs (1957)

Chinook: A History and Dictionary by Edward Harper Thomas (1935)

How When and Where On Hood Canal by Helen McReavy Andersen (1960)

The Seattle Times

Spillway 1994

Maritime Memories of Puget Sound in Photographs and text By Jim Gibbs and Joe

Williamson (1987)

The Sea Chest

Tall Timber Short Lines No. 80 Fall 2005

Pacific Lumber Ships by Gordon Newell and Joe Williamson (1960)

The History of Belfair and the Tahuya Peninsula 1880-1940 by Irene B. Davis (2001)

Early Schools of Washington Territory by Angie Burt Bowden (1935)

Guide to Ferryboats of Puget Sound Past and Present by Patricia Lander (2002)

Vapor Trails by Evelyn Sperber (1990)

The Wilkes Expedition (1987)

The Way it was in Kitsap Schools by Kitsap County retired teachers

Newspapering in the Old West by Robert F. Karlevitz (1965)

Index

About The Author

Born during the Second World War, Fred Just was raised in Crosby. He attended Seabeck Elementary School, and attended Central Kitsap High School. Fred joined the Air Force during the Viet Nam War and was stationed in Montana and France. In the Air Force he was trained as an Inventory Management Specialist in supplies, and then ran a research section. A few years after getting out of the service with an honorable discharge, Fred became interested in history both American and local. In the 1970's I joined the Kitsap County Historical Society becoming Publicity Director.

The next year Fred Just became Vice-president and the following year President. He was a contributing writer for the book "Kitsap Schools: The way they were", and helped with the "Kitsap County: a History". He wrote a feature article about Seabeck for a Northwest Magazine, he has also given talks locally and as far away as Grants Pass Oregon.

In 1971 Fred began doing research on the Seabeck Cemetery and the history of the surrounding area. He belongs to the National Thespian Society, and also has 2 awards from the Central Kitsap Fire District, a Certificate of Training for Disaster Control, a diploma in Organizational Supply, a diploma from the California Wine Institute, an award from Bangor Sub Base, Citizen of the year from the Seabeck Community club, Certificate of Recognition from the Veterans of Foreign Wars, and other training certificates. Mr. Just spent most of his employment

as a cook working up to Executive Chef. He was an Executive Chef in an Elks Club and also a Holiday Inn. For 19 years he owned the Camp Union Cookhouse. While at the Camp Union Cookhouse he received many write ups and was even mentioned in the Nashville Magazine.

Author Fred Just

CPSIA information can be obtained
at www.ICGtesting.com
Printed in the USA
BVHW042137100620
581285BV00006B/37/J

9 781942 661719